WOMEN
leading

sue hayward

palgrave
macmillan

First published 2005 by
PALGRAVE MACMILLAN
Houndmills, Basingstoke, Hampshire RG21 6XS and
175 Fifth Avenue, New York, N.Y. 10010
Companies and representatives throughout the world

PALGRAVE MACMILLAN is the global academic imprint of the Palgrave Macmillan division of St. Martin's Press, LLC and of Palgrave Macmillan Ltd. Macmillan® is a registered trademark in the United States, United Kingdom and other countries. Palgrave is a registered trademark in the European Union and other countries.

ISBN 1–4039–3676–5

This book is printed on paper suitable for recycling and made from fully managed and sustained forest sources.

A catalogue record for this book is available from the British Library.

A catalog record for this book is available from the Library of Congress.

10 9 8 7 6 5 4 3 2 1
14 13 12 11 10 09 08 07 06 05

Printed and bound in Great Britain by
Creative Print & Design (Wales), Ebbw Vale

To my lovely daughter Millie — I hope you'll be more impressed with my book than you were with my first TV appearance — watching the Teletubbies instead! And to Barry, who couldn't believe his luck when I started writing instead of talking for a living but put up with months of book writing while pouring me endless glasses of wine

contents

acknowledgements vi

chapter 1 WHERE TO BEGIN? 1

chapter 2 THE CHANGING ROLE OF WOMEN 13

chapter 3 BOARDROOM WOMEN: BREAKING
 THROUGH THE GLASS CEILING 28

chapter 4 HOW WILL MEN COPE? 49

chapter 5 WORKPLACE SKILLS 65

chapter 6 WOMEN IN THE HEART OF THE CITY:
 THE MONEY MARKETS 83

chapter 7 SISTERS ARE DOING IT FOR THEMSELVES 98

chapter 8 WOMEN IN THE MEDIA 114

chapter 9 WHO WEARS THE TROUSERS? WOMEN
 IN RELATIONSHIPS 131

chapter 10 WOMEN ON THE INTERNATIONAL STAGE 151

chapter 11 SIMPLY THE BEST 170

bibliography 180

index 183

acknowledgements

A huge thank you to everyone who gave up their time to be interviewed for this book, and especially those of you who kindly rescheduled when I was in bed with flu for most of December and had to cancel interviews because I could barely talk – a rare occasion indeed! There are too many people who have been interviewed, or have sent information or copies of books, answered questions and given permission for me to take extracts from their websites to mention, but thanks to you all. Hopefully you'll all rush out to buy a copy to see your quotes and advice in print.

Thanks too, to my wonderful friends who, on hearing I was writing this book, sent me cuttings of newspaper articles, suggested names for interview and put up with hearing detailed weekly updates on how the book writing was progressing. Thanks also to my Mum and Dad who over numerous cups of coffee came up with endless names and suggestions for interview – better stop thanking everyone now or you'll all expect a consultancy fee!

Every effort has been made to trace all the copyright holders but if any have been inadvertently overlooked the publishers will be pleased to make the necessary arrangements at the first opportunity.

chapter 1
WHERE TO BEGIN?

When I was first approached to write this book I was hugely excited at the prospect of such a challenge. Pretty rapidly the excitement and enthusiasm turned to doubt and concern over how I could possibly do justice to the vast issue of women's leadership in just one book. If it's taken us thousands of years to reach this point in time, how can you sum that up in just a few thousand words?

This book aims to examine women's ability to lead, how we lead and the skills we use in both our professional and personal lives. It also looks at whether after so many years of male domination, particularly in the business world, women have finally discovered the answer within themselves to being successful leaders. Are we finally realising that the answer lies in using our own unique female skills rather than falling down as we've done in the past by trying to copy the boys, bearing the weight of an outdated and ill-fitting 'macho' image that we previously felt was the only way forward in business?

Throughout the ages women have experienced so many changes; some have been of their own making, whether by

campaigning, for example, to secure voting rights or through changes brought upon them by external events like world wars. Naturally our lives have not all changed at the same pace; in some societies the level of independence that Western women take for granted may be many years away or possibly forever remain a dream for others.

But when it comes to women in business, which country would you cite as the one with the highest proportion of women holding down jobs in senior management? Would you come up with one of the major industrialised nations like the US, Canada, the UK or Australia? According to research published earlier this year in the Grant Thornton International Business Owners Survey, Russia emerged as the clear leader, with 42 per cent of its senior management positions held by women compared with around 20 per cent in the US and 18 per cent in the UK. Look further down the list and it makes for interesting reading. According to Grant Thornton's research, carried out in over 26 countries around the world, Russia also has the highest proportion of companies where women occupy management roles, at 89 per cent. That's followed by the Philippines with 85 per cent and the US, Mexico and South Africa all have 75 per cent of their companies where women hold senior management positions. Bottom of the list are the Netherlands, Pakistan, Japan and Germany, all with around 30 per cent.

While some countries may have a high percentage of *companies* that employ women in management roles, when it comes to the actual physical numbers of women winning

these jobs, that figure falls in all cases. We've already established that Russia has around 89 per cent of companies where women occupy management roles and 42 per cent of the country's potential senior management positions are held by women. America has 75 per cent of companies employing women in senior management but only 20 per cent of the country's senior management jobs are held by women. In Japan 29 per cent of companies employ women at management level but just 8 per cent of those potential jobs are done by women.

So while it's all very well trying to show the rest of the world that your country employs women in high-level business positions, what we must also look at are the actual numbers holding down those jobs compared with the numbers of men. Russia is really the only one to come close to a near fifty-fifty representation at 42 per cent. As we'll find out later in the book, some countries like Norway are trying to redress the balance by imposing female ratio targets which must be met.

Depending on your country and your culture, you might argue that women have come a long way in a relatively short time. Whether you want to interpret this as catching up with men or as regaining lost ground, just look back a few thousand years to ancient Egypt for examples of strong, forceful female leaders before the 'glass ceiling' was even built. The Egyptians were too busy building pyramids to think about building glass ceilings. In making such huge achievements within such a short time, and when I say this I'm thinking realistically of probably the last 100 years or so, it's created

the problem in the West that some women don't know how to lead. We're taking on and securing higher profile positions in the workplace, in government, as world leaders, icons and increasingly heading up households; sometimes it can be difficult to find our own way of leading, particularly when it comes to areas that have been previously dominated by men. How do we as women find the leadership skills needed to succeed in today's society?

Maybe in the old days when the old boys network remained largely unchallenged and women hadn't yet sharpened their stilettos ready to attack that glass ceiling, Professor Henry Higgins' line, from the 1964 film *My Fair Lady*, 'Why can't a woman be more like a man?' would have pretty much summed it all up. Many women might feel they've had to take on the typical male 'macho' style of leadership in their working lives or even within their relationships. After all, look at the shoulder padded suited and booted power dressing women we saw a decade or so ago. The pressure was on to do everything better than men; we tried to play men at their own game but instead of using our own unique set of tools we tried to do it with the wrong set; using men's tools and adhering to stereotypical traits even down to the way we dressed! Who knows how many of us who went along with the image of 'superwoman' and tried to embody that style of male leadership ended up burnt out, depressed or frustrated? Later on in the book we'll look at examples of high-profile women who have taken that conscious decision to step off the merry-go-round and spend more time at home with their families or pursue other career ambitions, for example starting their own

4

business. This is an increasing trend amongst women who are jumping ship and getting off the corporate ladder before they bang their head on the glass ceiling. So while some of us are deciding the way forward is to go it alone, for those left in the corporate culture it could mean the workplace ethos being forced to adapt in order to keep them and harness their female skills for greater success. Could we within a few years face a situation where women are a dying breed in the workplace just when our interpersonal skills are needed most?

I believe that when used to their full potential, women's natural skills and abilities can make them even more successful than men in the work culture. Quite a claim I know for the opening chapter, but in researching this book I've spoken to many people, both men and women, to try and discover what it is that really makes a good female leader. It's not necessarily about power and domination; true leadership is about strength of character, team building and inner reserves of emotional strength. Interesting too, as we'll find out later, there are now courses run specifically for men to redevelop if you like their own assertiveness and actively learn some 'female' skills to help them get on in the workplace.

Now clearly, when researching and writing a book like this, you could make it your life's work – I could travel the world for the rest of my life speaking to women from different cultural, economic and political backgrounds and quite literally spend years learning about their lives before even attempting to put pen to paper.

My own background is very media-oriented. I'm a broad-caster, presenter and journalist – I've presented on BBC radio and television and written for magazines and newspapers, usually covering consumer, money and workplace issues. As someone who has had the opportunity of interviewing hundreds of people over the years, I still find it absolutely fascinating learning about other people's lives. I love the fact that, under the guise of being a presenter and journalist, it's basically a licence to ask people questions about all aspects of their lives. When I've interviewed people on the radio or for magazine features, it never ceases to amaze me how many people have such truly fascinating stories to tell about their lives and, with just a little encouragement, it can be the difference between getting a good story or just having a pleasant but superficial conversation. That's not to say it's always easy to interview everyone; believe me I've sat in radio studios on at least a couple of cringe-worthy occasions and struggled to come up with questions to encourage a couple of sadly memorable and monosyllabic interviewees into action.

So while I don't profess to be a world expert in women's issues or to have travelled the length and breadth of the world in any lifelong research into women's lives, what I do have, along with my journalist experience, is my own personal experience as a woman.

Through my own life experience, and I'm not about to write my autobiography here, in my working life I've been given some wonderful opportunities at times and equally there have been times when some doors closed in a rather abrupt and

unexpected way. I'd like to think that I've used some of those opportunities and learnt from them. As a working mum with a six-year-old daughter I'm constantly having to juggle my work schedule, an aspect of everyday life I'm sure millions of parents will empathise with, plus the pressures that went with being a single parent for the first five years of her life. From my days spent backpacking around the world to being a mother, partner, broadcaster and journalist, it's all part of my experience and each of us through our lives has our own unique tale to tell.

Back to the book; it's not a textbook guide to great leadership. It's not a case of me trying to say 'if you do this, this and this then you'll be a great leader'. It's about exploring the different leadership skills that women need and that in most cases women already have but just don't realise their true potential or utilise them to the utmost.

So in writing this book what I hope to achieve is really a sense of pulling together different perspectives on women's role in society; but equally to challenge society's views on women. In reading the book I'm sure you'll identify with some of the women featured in it; they may have had similar experiences to your own but clearly they won't all emulate your own life because that's yours, it's unique. I believe it's only through our experience of life that we can truly understand and appreciate other people's experiences and lives which leads us to be more open-minded.

There's no right and wrong way for looking at things; where one woman might view redundancy, a relationship break-up or a disabling accident as the most traumatic event in her life and something that she never expects to recover from, another woman will deal with the experience but try to overcome it and move on, in time and in many cases to greater and better things. How we overcome obstacles in life is very much down to our own core personality and inner strength. As women, and men, our perception on life is unique. I'll give you an example, when I was travelling through Australia some years ago I got the chance to watch the sun set over Ayers Rock in one of the most remote and far-flung parts of Australia. It was one of the most amazing sights I'd ever seen, yet meeting an American girl the next day who'd also witnessed the sunset, she complained that she'd spent days travelling to see it, how disappointing it was and how she bitterly regretted the fact that she'd bothered to make the trip. I couldn't believe she hadn't been overawed by the experience and began to wonder if in fact we'd even been at the same place but it just goes to prove that our perception is personal and unique to us.

In reading this book you may find some chapters more relevant to you than others, some parts may strike a chord with you and I hope that everyone who reads it will find some aspect to take away with them.

When it comes to the differences between men and women, there's an entire industry built around the subject and under-standing our ways of thinking. Just look at the huge numbers of self-help style books available in most book shops; the hugely

popular *Men Are From Mars, Women Are From Venus* (1993) by John Gray sold over thirty million copies around the world and has been published in over forty languages. Equally, over the last few years I seem to have noticed a spate of books written by American women on the subject of caring for your husband and how to be the perfect wife. The latest one to hit the headlines is Dr Laura Schlessinger's *The Proper Care & Feeding of Husbands* (2004) on how to be the perfect partner, with at least one newspaper reviewer describing her views as 'politically incorrect'.

Highlighting the fundamental differences in our male and female ways of thinking has produced big screen blockbusters too – remember the romantic comedy *What Women Want* starring Mel Gibson and Helen Hunt? Gibson stars as chauvinist pig Nick Marshall, a man who wants to be big in advertising but has a newly appointed female boss. Marshall has never really tried to understand the female psyche, probably never had any need to, but after a freak accident he's landed with the natural ability to hear every thought that women think, with humorous consequences. In fact the truth could be closer than fiction, because at Cambridge University research suggests that while the 'female' brain is said to be focused more on empathy and the 'male' brain on systems, there may be cases where some of the traits traditionally associated with either gender could be transposed. This may help us to explain why some masculine men are in touch with their 'feminine' side and equally some women can be successful in the so-called 'man's world'.

Throughout the book we'll also look at what makes a good female leader. Men have historically been able to lead in their own way for so long that, when faced with the new 'female'-style leaders who don't fit the traditional mould, one could ask 'are they trying to hold women back because they're unable to recognise leadership skills unless as a mirror image of their own?'

There's also an element of the fact that before you can lead anyone else you need to lead yourself; in other words, you need to be strong enough and confident enough in your own abilities, skills and strengths and in yourself as a person before you can expect to successfully lead others. Let's face it, nobody will follow an insecure leader or anyone whose confidence they feel is wavering. We all want to be reassured, to feel secure, whether in our relationships or professional life. Just look at babies; if they don't feel secure and loved, they'll cry for attention; pretty much the same happens in the workplace a couple of decades down the line. If the workers don't feel looked after – well-treated, respected, well-paid and valued – they might well go on strike! Nobody wants to work for a boss, be they male or female, who doesn't inspire or appreciate them.

This brings me to some of the problems that women face in the workplace today. In working with men, are we also trying to emulate them too much in the social side of business? Women too are now heading for the pub on a Friday night and in fact many women openly admit that they're drinking more because of the work culture. With women working long hours in stressful and demanding careers, alcohol often serves as a

crutch – a way of coping and boosting their confidence – and like it or not it's often intrinsic in oiling the wheels of business. Let's face it, a bonding session down the pub is something men have indulged in for years. In trying to keep up with the boys, many young women, it could be argued, have taken on some of the harsher male traits; swearing, smoking, indulging in casual sex and aggressive style tactics rather than trying to develop their own personal skills. In the same way that playing the little girl lost, complete with fluttery eyelashes, won't do you any favours if you want to be taken seriously in the workplace, then playing the macho man role as a woman, I believe, can have an equally damaging effect on your career.

Later on in the book we'll also look at whether some nations work harder at encouraging women to go further. For example, Barbara Cassani, formerly a big force in the airline industry and now responsible for heading up the 2012 London Olympic bid, is American and Dame Marjorie Scardino, chief executive of Pearson, the international media group, was also born in the US and remains the only female chief executive in the FTSE 100 leading companies, according to research by Cranfield School of Management (2003).

I also think it's important to look at the whole issue of whether women really can have it all. Sadly I don't think we can unless you're willing to head for burnout. Having a full-time career, bringing up children and trying to squeeze in that bit of 'me' time, plus the odd night out with your partner, is pretty much an impossible combination unless you've got a

willing army of cleaners, childminders, maybe the odd personal assistant thrown in, plus the money to pay for it all. If you haven't got to go home after a long working day and cook a meal or worry about making sure the kids' school uniform is washed, alongside trying to ring your best friend who's having a traumatic time and actually asking your partner how their day was, you might be OK but, for millions of parents, and I'll include both men and women in this, it's tough. Sadly, and this isn't me being sexist, in the vast majority of cases – and certainly amongst many of the women I've spoken to – the running of the home, remembering to make sure there's enough food in the fridge for the kids' packed lunch and the general day-to-day organisation does fall to the woman. While it may be possible to 'have it all' for a short time, unless you've got a really good support network through family and friends, or the money to pay for it, I think many women potentially risk burnout or at least permanent levels of stress.

In ending this introduction, I'd just like to say that I haven't forgotten the men out there – around half the population of this planet no less – and the last thing I'd want this book to be is some kind of feminist approach to life and leadership! This book isn't about saying how wonderful women are without fact or proof and it's going to highlight women's failings as well, so it may not always be a comfortable read but hopefully it will be an inspiring one.

chapter 2
THE CHANGING ROLE OF WOMEN

Women in business have traditionally been seen as falling into two camps; those that flirt their way to the top and those that get there by being 'ballbreakers'.

Look at some of the female business leaders of more recent times – Penny Hughes of Coca-Cola, Carly Fiorina of Hewlett-Packard, Oprah Winfrey, Anita Roddick, founder of The Body Shop, Sally Krawcheck of US-based Smith Barney and Clara Furse, the first chief executive of the London Stock Exchange. Flirts or ballbreakers – you decide – or in fact a new breed of confident successful women who've reached the top of their chosen profession with their own personal style of leadership.

Those old stereotypes are now somewhat outdated and women have realised that you can get to the top without going 'over the top' on the female charms and without adopting some of the more dominant and macho traits of the old school style of male behaviour. But historically it's easy to see why women often felt compelled to adopt one of those two stereotypes;

after all if the existing and previously successful blueprint for top management was that of the stereotypical male boss, then why would any man at the top want to change that by inviting women in? If companies wanted to repeat their previous track record in business, the logical answer was probably to minimise the risk by sticking to the tried and tested pattern of management and promoting staff who best fitted the existing director mould; that of a traditional male leader. When questioned about the lack of women at the top, typical responses from companies include criticism of women's commitment, confidence, dedication and lack of self-promotion. Bear in mind, however, that these criticisms are being made by men. Russell Reynolds Associates, a headhunting firm, is said to have revealed that there's little demand for women to be included on UK company director shortlists but, by contrast, in the US headhunting women bosses is a major part of its business.

Are you more likely to be taken seriously as a woman in business if you've got a title? Cranfield School of Management's Centre for Developing Women Business Leaders highlighted the only female chief executive in the UK FTSE 100 companies as Dame Marjorie Scardino of Pearson and the only female chairman as Baroness Hogg of 3i – both titled women and the only women holding down those positions within the UK's top companies.

This chapter looks at women's changing role in society and the knock-on effect in business. From the days when no woman could expect to progress further than the typing pool, women now can and have secured for themselves roles as chief exec-

utives of multimillion-dollar companies and also made millions
setting up their own business empires. The number of women
in these positions is still heavily outweighed by men in many
if not all countries, but even in countries like China, where
progress for women has been slower than, say, the US or
Europe, the business environment is changing. Even ten years
ago in China there were over eight million women working in
the science and technology industries; that's 25 per cent of the
total employed in China across these sectors and even then
women accounted for 33 per cent of university graduates.

Cultural differences play a huge part in the potential success
of women in business. Where, within one country or culture,
a woman working, say, in a family company might well
expect to take over the business one day, within the Hindu
culture, that situation would be extremely unlikely, putting the
woman, however intelligent and successful she may be, at a
distinct disadvantage. This was illustrated in a recent high-
profile, bitter legal battle that tore apart the multi-
million-pound Patak Indian food empire after two of the
daughters claimed they'd been cheated out of their shares. The
sisters claimed that the shares had been given to them by their
father and took action against the current company boss who
was also a family member. Their argument was that they'd
been victims of the Hindu culture where business assets go to
the sons so their claim had not been acknowledged.

A woman's input is often vital to company success these days.
The previously unrecognised and unacknowledged 'soft' skills
like communication and team building that women possess are

now seen as vital within many companies when it comes to strengthening relationships within the company. Take an example typical, I think, of many of the old school men in business; if they can sit at their desk and get away with sending an email to someone three doors away, they'll go with that option, while women are more likely to get up and go round to see the person face to face. Women think about how to boost morale and encourage better workplace relations. Another example is The Body Shop, started by Anita Roddick, which has a policy of giving staff a £100 bonus each year to 'love themselves'. It can be used for college courses or pampering treatments and, as a gesture, it has earned the company a reputation for looking after its employees.

In many cases, change in any aspect of life may be attributed to external factors, World events like wars can be a catalyst for change when it comes to women finding greater independence and realising their true potential. Many women find that life events like relationship break-ups, redundancy, promotion or childbirth act as a catalyst for change that spills over into other aspects of their lives or at least makes them think long and hard about the direction their lives are taking. When you think of the multicultural world we live in today, and the multiculturism to be found in, for example, the cosmopolitan cities of London, Sydney and New York, there are millions of women shaping their own future, often within another culture or within a country not of their birth. In today's society women are increasingly making conscious decisions about their lives and taking responsibility for their actions. The decisions around whether to stay single or celibate, start a family, adopt

or be sterilised were often previously enforced upon women according to their culture, but in many cases they now have freedom of choice. In some cases there may still be pressure from family or peers in certain cultures to marry at a certain age or have children. The average age for women to marry is increasing in some countries; across the European Union the average age for marriage for both men and women has risen over the last 40 years by around four years.

As well as making decisions about marriage, women are also able to make choices about whether to stay at home and bring up a family or go out to work; even the disposable income that many women in the West command gives them far greater freedom of choice than our grandparents' generation. But while women in some cultures are afforded that freedom as to whether to go out to work, for others work is a necessity in order to support their family.

Old clichés like 'life begins at forty' may never have been truer for some women; as we can now expect to live till around eighty, far from forty or fifty plus being a stage in life when everything goes southwards, it can often mark a new beginning. Some would say the 'older woman' has never had it so good. When it comes to turning back the clock on your looks, cosmetic surgery is now not just the preserve of the rich and famous but a viable and affordable option for many women. For some it's as easy as getting a bank loan, chalking it up to their credit card, while for others it could be a birthday or Christmas present from their partner. When it comes to turning back the clock, instead of forming relationships with

older men, many women are having relationships with younger men. It's not just celebrities like Demi Moore who've been spotted on the arm of a younger man; it's becoming more commonplace and not such an eyebrow raiser for a woman to be in a relationship with a man who's a few years younger.

In recognising women's achievements, International Women's Day was set up as a global celebration to focus on the economic, political and social achievements of women around the world. Within each country, different events are organised, usually with a particular focus on that country. In some countries, the day itself may be a national holiday but the whole idea of it is that women around the world, who may be divided by their upbringing, political aspirations, cultural background, race or social boundaries, can come together on one day and celebrate womanhood. According to the United Nations, the first National Women's Day took place in the United States in 1909 and just two years later International Women's Day was marked for the first time in Austria, Denmark, Germany and Switzerland, where over one million attended rallies. Russian women observed their first International Women's Day in 1913 and in 1977 the United Nations added its support to a day for women's rights and international peace.

Each country organises its own events and has its own specific focus. While in many countries International Women's Day may be a time to look back and celebrate women's struggle for equality, recognition and success, if you look at other cultures, in fact as far back as ancient Egypt, it actually

could be said that women once really *did* have it all. While we might think women have gradually achieved more over the years, in terms of recognition in society and in the workplace, maybe all we're actually doing is trying to recreate and reachieve what we once had but seemingly lost.

Go back to the days of ancient Egypt and you'll find that Egyptian women weren't a meek and mild race. In fact, from everything I've read about these women, it seems their power and determination was quite unrivalled in the ancient world, particularly one that set such store by male prowess. Read any history book on ancient Egypt and you'll find stories of women generally assuming an equal role to men and even being seen to challenge enemies in what could be described as an aggressive role; certainly not a traditional 'female' trait. In fact it's believed that Egyptian women were on an equal footing with men when it came to their pay packet; a contro-versial subject that even today many societies struggle with. Interestingly enough, even in paintings, an Egyptian wife is always pictured alongside her husband and their children. It wasn't a case of the wife being seen and not heard; Egyptian women were a tough lot.

Even in business they didn't do badly either; Queen Heteph-eres II ran the civil service and there were several female Egyptian rulers including Pharaoh Hatshepsut who's believed to have reigned for around 15 years. Some of the more well-known or much written about women include Nefertiti who is believed to have ruled independently following the death of her husband and Cleopatra herself who is credited with

restoring Egypt's fortunes before committing suicide in 30BC. Yet over a few thousand years this kind of freedom, independence and recognition afforded to women in Egypt changed and when you look at Egypt today a woman's role is much more oriented at home around her family, with many women brought up not to expect a great deal more. It's a bizarre sense of a complete turnaround where as women we seemingly once 'had it all' and then lost our power. So are we really just struggling to regain what we once had?

Clinical psychologist Janice Hiller says there's been a huge cultural change over the last 20 years alone and it's now increasingly common for women to do the changing in relationships. Divorce rates are up and much has been made in the media about the concept of the 'mini marriage', where people marry for the first time at a young age, not consciously experimenting but almost 'dipping their toe' into the water, before attempting a second marriage later in life once they're more established in both their personal and professional life. Although Hiller says that's not an ideal anyone would aspire to, she says the problem is more about the reality of life:

> for example women working, wanting to have a social life, have friends, have children and have a marriage – the reality is that's terribly difficult and the central relationship, the marriage, can suffer.

When it comes to Hollywood marriages, where one partner is often working half-way around the world while the other is being flung together with some of the most beautiful people in

the world, it's hardly surprising that so many of them falter at the first hurdle. Even a superstar such as Kylie Minogue has been heard to bemoan the difficulty of relationships because of the importance of her career and the relentless schedule.

Another change that goes in women's favour on a personal level is the ready acceptance of divorce in some cultures. The divorce laws have been relaxed somewhat in some societies, for example in the UK, so that it is easier to get divorced and even online divorce is now available, almost as easy as filling in a form online and sending it off with the fee. This may appear to be a very superficial view but if you haven't got children, divorce can be a fairly clean-cut affair when it comes to dividing your assets. Being a divorcee is no longer talked about in hushed tones and it's not frowned upon to have a marriage behind you or for women to have had several sexual partners during their life, all of which would not have been mentioned or tolerated in days gone by.

Women's sexuality is another huge area where obviously opinions vary greatly according to culture and upbringing. The barbaric and wholly abhorrent practice of female circumcision has been carried out across parts of western and southern Asia, the Middle East and parts of Africa. According to one BBC report, an estimated one hundred million women worldwide are said to have been exposed to this treatment. Supporters of the practice say it's done for cultural and religious reasons, but not only can it be life-threatening as it's often carried out by untrained people but it is also probably the most extreme form of oppression for women. Yet while women in some cultures

endure this bloody and barbaric act, in others teenagers are free to buy teen magazines where they can can learn pretty much anything about sex. Many teenage girls' comics or magazines seem to have become mini versions of women's magazines at a younger and younger age, and now include articles about what to do if their boyfriend wants sex and they don't. Of course, when it comes to bringing sex out into the open, the women's magazine *Cosmopolitan* surely has to get the credit for being the one that did it first. It currently sells in around 28 countries and is still going strong, selling around four million copies worldwide.

But in trying to push ahead, break down the barriers and ensure that we're always on an equal footing with the men, we shouldn't forget that not every woman relishes that role! Some would argue that the one factor standing between men and women's equal success in business is hormones. Let's face it, *most* women at some stage in their lives want to have a family and, like it or not, you've got to be prepared to accept that there's a price to pay on your career. In many cultures women are still considered responsible for bringing up the family, which means we're back to the age-old problem of how to combine a career with family life. Putting your career first is acceptable behaviour for a man but society is much less tolerant of women who do this. Hence the image of 'superwoman' that just isn't possible. Even Cherie Blair, the wife of the UK prime minister, has publicly admitted to the pressures of struggling to combine her roles as wife, mother and barrister. But while there's the ongoing issue about why more women aren't running the top companies,

clinical psychologist Janice Hiller says we must remember that not every woman wants to do that:

> Lots of women don't want those very long hours or that responsibility, a minority do and there is a big shift in the whole balance of relationships but I think it affects a minority of women.

She says there are still a lot of very traditional relationships:

> I think sometimes there's a minority of girls doing very well in the cities who are very different from lots of women who have a very traditional view; I think we can get a very skewed view of it.

I'm sure in most women's lives there comes a point where they think, 'I'm happy now, I'm where I want to be' and they are quite happy to stay there. Whether it's within their career or family life, they reach a point where they're happy with their lot and want to sit back and enjoy it. Surely that's one of the best things in life to be able to achieve? After all, you can watch any documentary about a fallen celebrity or someone who seemingly had it all only to become addicted to drink, drugs or sex, and when questioned they'll admit it was in the constant pursuit of happiness and their desperation to achieve that ideal.

In some cases, I think the external pressure exerted on women to make them feel that they ought to be looking for something else or considering a promotion at work because if they don't they could lose respect is very strong. I remember years ago

in my Saturday job meeting a lady who loved her job; she worked in a shop. She wasn't a manager or supervisor, in fact she held no position of responsibility yet she was happy. She didn't have to work long hours or face pressure about what time she went home, as once the store shut the staff were out the door pretty smartish en masse. Yet I can remember people trying to persuade her to try and get promotion; to apply for a supervisor's job. Although that position might have given her more money, she clearly didn't want it – how sad to feel pushed and pressurised into a life you don't want. So I think there's a point to be made that while some women want to achieve more and have high aspirations and ambitions for their lives – whether it's a bigger house, having a family or climbing the career ladder – we must recognise and be tolerant and supportive of women who don't want that.

It's the same story when it comes to starting a family. I lost count of the times, before having my daughter, that I'd been asked by people when I was going to have children and how many I wanted, just because at that time I was in a long-term relationship. In some cultures women are choosing to have children later in life and according to some research carried out by the Future Foundation, a consumer think tank, the traditional view of family life could be rapidly going out of the window. It predicted that within five years childless couples living together could outnumber family residences, yet just 40 years ago the family unit, consisting of couples with dependent children, made up half of all UK households. For further proof of the fact that women aren't growing up with the ultimate aim of getting married and starting a family above all else, just look at the

way in which people choose to get married. I think it is a very telling fact that whereas once it might have been the traditional white wedding largely paid for by the bride's parents, these days couples are much more likely to pay for the day themselves and get married almost anywhere and everywhere.

And while we're on the subject of money, let's look at who is earning it. A study by Datamonitor revealed that within the UK there were more female millionaires than men. Women are increasingly taking on the role of breadwinner; whether within a relationship or by bringing up a family by themselves. Philippa Stephen-Martin is 37 and mother to 12-year-old Mia. She lives in Brighton and says she's always been the bread-winner, either with or without a man in her life; in fact with her previous husband she was the breadwinner for the three years before having their daughter. Although she's now with another partner, she was a single parent for many years, during which time she set up her own award-winning business Cbabiesafe, a unique baby nursery where parents can check on their children via specially monitored and secure web-cams throughout the day. The business now has a turnover of over a quarter of a million pounds, yet at one stage Philippa moved into the property with just £80 in her pocket.

But look beyond her present award-winning business and it hasn't always been that way. Over the years Philippa's done numerous jobs to bring the money in, from working at airports to sales and buying and letting property, where she got her fingers badly burnt after the housing boom turned to bust in the late 1980s and early 1990s.

I lost a lot of money and was chased up for about £50,000 by a company for a long, long time – because although I'd bought the house for £45,000 it was finally sold for just £15,000.

She ended up in rented accommodation and where most people would have rolled over and given up she still had a desire to get up and start over again.

In some industries and particularly those dominated by men, it can seem a slow battle for female recognition. When looking to buy a house to set up her nursery, Philippa claims estate agents kept trying to sell the property to other people despite the fact she was putting in higher offers than any other bidder. She was constantly asked whether she had a husband or partner and says that even on meeting her current partner Andrew, who is from the Caribbean, he couldn't get his head round the concept that it was all her own business and she'd earned every penny of it herself.

I think he came round expecting some husband to jump out at him. Andrew's from the Caribbean so it's a completely different way of thinking over there; they don't expect a single woman, particularly with a child, to have accomplished so much.

The turning point for Philippa came when her mother read her an article about Richard Branson:

He said if you haven't made it by 35, you never will – and it gave me a kick-start. I always expected something more out of life; I never expected to be a single mother but you never do. I just thought I've got to do something; I've got to get on with my life; I can't wait 16 or 17 years or put up with some job that won't give me the quality of life that I want to give both myself and my daughter.

In the early days she had 17 students living with her and her daughter in order to make some money to pay off the huge mortgage. It's this tenacity and drive to succeed against the odds that has earned her the Natwest Everywoman Award 2003.

The stereotypes of the permanently glamorous and polished, short-skirted female executive or that of the battleaxe have now given way to a more realistic picture of women who are prepared to work hard for their success. Maybe while the current chief executives and chairmen remain those of the old school views, it could for a short time still remain harder for women than men to break through that glass ceiling but that must change. Young men don't buy into the old stereotypes; many of those below 50 have wives, partners or even mothers who hold down jobs or careers and consider their female counterparts as colleagues rather than someone whose role is nothing more than to fetch their coffee or type their letters. Could it be that, by the time the current dinosaurian breed of top management finally retire, for the first time women really will stand a chance of securing an equal footing on the career ladder?

chapter 3

BOARDROOM WOMEN: BREAKING THROUGH THE GLASS CEILING

'What do you want to be when you grow up?' It's probably one of the most hated questions for children the world over and is frequently asked at intervals in their early lives by doting relatives, school teachers or friends. While in general the boys, according to culture, continue to come up with ideas like rocket scientist, pilot or racing driver, some of the girls in turn might suggest a teacher, air hostess or nurse; typically the traditional 'female' caring professions. But how many of us at an early age would have harboured any ambition to become a company director or head up the board of management at a global multinational company?

Chances are, not many of us. The traditional 'job for life' security enjoyed by previous generations is now relatively outdated and rapidly becoming extinct in the corporate world today, thanks to the introduction of downsizing, mergers and

takeovers. But I think, in many cases, despite this huge change in the work culture, the career path you choose in your early years can have a real make or break effect when it comes to your future climb up the corporate career ladder.

While it's now socially acceptable for women to make up a large proportion of the world's workforce, when it comes to climbing the corporate ladder, how many of us have had to hang on for dear life swinging from that first rung? The world's boardrooms are sadly lacking in women and much has been written over the years about the sexist 'glass ceiling' that hampers women's success beyond a certain point in their career. While for men the glass ceiling may be just a myth, for many women it's a source of real frustration and can potentially spell the end of their career unless they can find a way to break through.

Let's take a look at the jobs that these women are doing. According to research from the Australian Equal Opportunities Women in the Workplace Agency, women across Australia have carved out great success for themselves in the traditional support roles, areas like human resources, the legal profession and public affairs but the Women in the Workplace Agency claims they're not the sort of jobs that are likely to lead to chief executive roles within major Australian corporations. There are still many women the world over stuck in the low pay ghettos of cleaning, clerical or caring, with no hope of getting out because of their education, class or upbringing. Traditionally women in the workforce have often been the second-class citizens; think of the inhuman conditions that have been highlighted in sweat-

shops in Southeast Asia, where workers have been found making clothing or toys for peanuts. Even in the West, it's not that long ago that women working in the match factories in the East End of London were subjected to unhealthy and dangerous conditions that caused long-term chronic illnesses.

Corporate Canada can only claim that around 11 per cent of its boardroom positions are held by women and in Australia, despite the fact that 44 per cent of the workforce is female, only one company director in ten is a woman, according to a discussion on *The World Today* programme broadcast on Australian ABC Radio. In the UK there are around thirteen million working women yet just 18 per cent of the senior management positions in the country are held by women. It's a picture that seems to be repeated the world over. Many countries including both Canada and Australia have roughly equal numbers of men and women making up the country's workforce, yet when it comes to the top jobs they seem beyond the grasp of many women.

In Chapter 1 I touched on some research from the accountancy firm Grant Thornton in its International Business Owners Survey that showed although the US may be a force to be reckoned with when it comes to economic power, when it comes to girl power in the company boardrooms, it's lagging behind other countries, for example Russia. The International Business Owners research revealed that around 40 per cent of the top management positions in Russia are held by women compared with around 20 per cent in the US and 18 per cent in the UK. Of course there are numerous social, political and

cultural differences that could contribute to these figures; not least the ongoing battle over the difference in salary scales between male and female workers. Both sexes can be doing the same job but, in some cases, women are paid considerably less than their male counterparts. Could one fundamental reason be the lack of provision for childcare in some countries which prevents women from returning to the workforce in full-time positions? The provision of state childcare in some countries and the culture of the extended family in countries like Italy enable women to return to work without fighting for childcare places. According to the Daycare Trust in the UK there's around one childcare place for every five children under the age of eight, so without adequate childcare facilities, the chances are that mothers will look for alternative careers, work part time or job share, all of which can be hard positions from which to later progress to the boardroom.

Within Russia 90 per cent of women aged between 35–49 are working or actively looking for work, but the majority of working women are in salaried employment as opposed to running their own businesses. The UN International Labor Organisation (ILO) claims that Russian women make up nearly half the country's working age population. There's still an element of the more prestigious jobs going to the boys; prior to the 1990s much of Russia's state-run banking system was predominantly run by women but since reforms to the industry, many jobs have been seen as more lucrative and prestigious and hence taken by the men.

So let's get to the crux of it. Why can't women secure the top jobs? There are several issues here. Firstly, I think there's the huge and widening gulf between the perception of whether a woman can successfully take on a management role and her actual talent, ability and skills for doing so. There's also the changing culture of the workplace; the traditionally 'female' skills involving communication and team building are more essential today than they've ever been, which could actually put some traditional male 'macho' men at a disadvantage as their traditional empire crumbles around them. In the workplace chapter we'll find out just how crucial to business today the traditional female skills have become as the dynamics of the work culture have changed. But let's first look at why there still seems to be a lack of women in boardroom positions and what, if anything, is being done about it.

We've looked at other countries around the world, so let's take a look at just how many women there are in top management positions across the UK. According to research (2003) from the Cranfield School of Management's Centre for Developing Women Business Leaders, the number of female directors across the FTSE 100 companies topped 100 for the first time in 2003; a total of 101 to be exact. It's an increase of 20 per cent, up from 84 in 2002, yet there are still 32 companies with no female directors.

Professor Susan Vinnicombe, Director of the Centre for Developing Women Business Leaders, says that despite the increase in female directorships across the FTSE 100 companies, there's still a long way to go:

I think there's got to be major change at the top and in terms of the whole process of selection and recruitment into the board; in general it's very informal and a very closed process so women don't stand a chance in that environment.

While you might think some companies, say those in the retail sector, would be keen to include women on the board, according to Professor Vinnicombe the number of women in top positions can be down to nothing more than how switched on the man, or woman, at the top is:

'it comes down to whether the top person in the company is committed to diversity and if so then there's diversity at board level'.

Surely our success on the corporate ladder comes down to more than just the prejudice and insecurity of those at the top of the tree? Vinnecombe's opinion is echoed by Pam Smith, national chairman of Women in Management, a national support organisation with 15 groups across the UK, who says:

Men who've been brought up seeing themselves at the top and women down below have great difficulty coping with the women at management level. I think they feel threatened and out of their depth with that type of person. The more confident men will happily take on women in the boardroom and I've worked with men who do accept women on an equal footing.

While clearly not every working woman has designs on reaching the boardroom or starting her own business, there are still a number for whom recognition, promotion and long-term success in the workplace are being hampered by the seemingly very real and very evident glass ceiling. Pam Smith of Women in Management again:

> The glass ceiling is still there, but it's disappearing in a number of places, there are definitely some cracks and women now have that confidence to go out and put themselves forward knowing that they're able to do a job and to do it well.

When it comes to the top people laying down the foundations for diversity and pushing for more women in key roles, companies that come to mind on the international stage include the multinational Anglo-Dutch company Unilever and Canadian media and entertainment group Corus Entertainment. Both have very forward-thinking people at the top. Unilever Chairman Niall FitzGerald KBE highlighted the need for diversity and more women within the organisation at a speech he made in Geneva (2003) at a women in leadership conference. Unilever has made great leaps in its drive to promote more women into the boardroom; ten years ago just 11 per cent of managers were women, now that figure has risen to 29 per cent. The ice cream to washing powder group grew out of a merger between a Dutch margarine company and British soap maker Lever Brothers in the 1930s – brands today include Marmite, Persil, Flora, Magnum and Lynx, with a company turnover of around thirty billion pounds a year and around a quarter of a million staff working for the company globally.

In his speech, Niall FitzGerald claimed that women are now in a unique position with the 'tide running in your favour', as we are highly skilled in both the emotional and spiritual field; areas where business is changing most rapidly. Putting its money where its mouth is, Unilever now has women on the boards in countries such as Ghana, Nigeria, Kenya and China. Its Pakistan business is headed up by a woman as are the Czech and Romanian sectors of the company. There are also female managers in Saudi Arabia.

One of the most basic concepts in business is that in order to succeed you've got to be able to relate to your clients or customers. As consumers are at the heart of Unilever's business, the company says it believes its leaders need to be a reflection of its consumers. This leads us to why Unilever are keen to include more women in their management team. FitzGerald says:

> Put simply, women have different ways of achieving results. There is a feminine approach to leadership, which is not of course confined to women. It is about being intuitive as well as rational. It is about multitasking. It is being sensitive to people's needs and emotions. It is about relationship building and generous listening.

So it seems that the need for more women in business isn't just down to equality and attempting to have a balanced workforce in today's politically correct society, but is also down to the fact that because of the way the work culture has changed, female skills are essential if companies are to succeed.

Rhodora Palomar-Fresnedi, vice-president in the strategic centre for human resources at Unilever, says women are the key to a company's success when it comes to developing relationships with clients and within other companies. She believes women now have a crucial role in business because the business environment has changed. Gone are the days when a management role meant nothing more than hiring and firing from behind the office desk without ever visiting the shop floor. The way forward in business is developing relationships, company mergers, corporate entertainment and keeping clients; not just abandoning them once a deal is done. One of our great strengths as women is in developing and strengthening relationships, which is a hugely marketable skill in business terms.

Men in turn have their own skills that can be harnessed in different roles. Palomar-Fresnedi says that when it comes to being 100 per cent focused on a situation, then men come out on top:

> They're naturally wired to have one thing going one hundred per cent and to do it well. I think if they've got ten things going at the same time it's more difficult for men. Women seem to do well in situations where they need to juggle different projects. That's just in their nature.

And what better 'juggling' act than the new mother; faced with the job of being all things to everyone at the same time, partner, wife, mother, daughter, employee and general cook, cleaner and chief dogsbody! Instead of writing women off once they've had children, Unilever has recently introduced a Mum's CV, inspired by Linda Emery its UK diversity

manager, whose own experience and ideas are now shared across the whole company. The Mum's CV lists skills that mothers are likely to develop and use at home with their children that in turn can also be used in the workplace. Rest assured that doesn't mean returning to work as the office mum, taking on tea making, desk tidying, organising leaving collections while producing a constant supply of headache tablets, plasters and a shoulder to cry on!

Time management, coaching, organisation, people management and even balancing the budget are all vital skills that are needed both at home and in the workplace. Take just one example, time management. If you've ever had to organise getting a child to school, while preparing another baby's bottle, ringing the doctor and trying to book the car in for a service while finding time for the weekly supermarket shop, you'll understand where the Mum's CV is coming from. The idea is that there are numerous skills women, and men, develop while looking after children that can be harnessed into positive skills on returning to work.

The last taboo in business can be the fact that, at times, if you've got a family, they may, horror of horrors, expect you at home at a certain time each night. Sadly sometimes with small children it can be hard to make it beyond a certain level in the corporate hierarchy because it's assumed you'll have to leave the office by five, need time off when the kids are sick or need to juggle your leave around an assortment of sports days, nativity plays or half-term holidays. There have been some women who've succeeded but in general it's those with

the money to pay for professional childcare and usually live-in nannies. Nicola Horlick, dubbed the city's 'superwoman', has a husband and family and held down high-profile jobs at Morgan Grenfell and SG Asset Management but, as she readily admits in interviews, she had the luxury of having the money to pay for a nanny and secretary to organise life for the family while she was in the office.

Having said that, some women claim to succeed despite refusing to hand over their lives to the corporate culture. Charlene Begley is the president and CEO of GE Transportation Systems, part of the huge multinational General Electric group which has over 33,000 employees in 40 countries. Charlene is said to have announced to colleagues at a networking conference back in 1999 that she doesn't work weekends. As a mother of three children that's maybe fair enough, but it seemingly hasn't hampered her path to the top. According to an interview in the American *Business Week,* she claims to never have encountered sexism on her way to the top, although she does play golf. Bearing in mind that closing business deals can sometimes go hand in hand with a round of golf in the male world of the corporate culture, this could be where she does at least retain a foot in the male work culture. If her comments are to be believed, Begley doesn't work weekends but she has worked in something like 20 locations over 15 years and only taken a six-week maternity break. This is an example of a woman who seems to have worked her way up through the company ranks, joining in 1988 on a financial management programme after graduating from the University of Vermont.

That somewhat flies in the face of criticism from those who say that many women are pigeonholed for life in the role they start off in. Come in on day one as the secretary and you can never expect to make it to the chairman's office – or can you? Is the illusion of working your way up in the world from humble beginnings as a secretary to a top management position really achievable or is it reserved for the movies?

In Hollywood, of course, anything is possible; remember the film *Working Girl* starring Sigourney Weaver, Harrison Ford and Melanie Griffith? Griffith starred as Tess McGill, the hard-working secretary who came up with a brilliant takeover plan but once the concept fell into her boss's manipulative hands she fears a lifetime in the typing pool. Luckily, as it's the movies, she meets up with Harrison Ford and they put the deal together. Griffith winds up with her own office, her old boss gets the boot and it's a great story of girl power, but can it happen in the real world? Clearly in the case of Charlene Begley at GE Transportation Systems it can.

Switching careers isn't always harmful to your long-term prospects either: The Body Shop founder Anita Roddick was running a hotel with her husband before starting her environmentally friendly cosmetics empire. Even in my own career I've managed to short-circuit the system simply by taking time out from the loop which enabled me to jump up another couple of rungs on the career ladder. In my early days in the industry my goal was to be a researcher but I just couldn't seem to win that elusive job while I was a production assistant. I'd applied for a couple of jobs on different radio shows and been unsuc-

cessful but, ironically, after leaving my job to go backpacking round the world, I rang my old boss on my return asking for freelance work and he immediately offered me a couple of days research on the new weekend current affairs show! Two days turned into a week and then a couple more weeks, a month and ironically I'd achieved what I'd first set out to do, hopefully with the relevant experience but having enjoyed the experience of travelling for six months too!

There may be a case, as we've already found, for some women to rise through the ranks of an organisation, but if you leave and gain experience elsewhere, whether through a sabbatical, attachment or working for another company, it often makes you much more valuable and with an added wealth of experience. If you don't intend leaving the doors of the company until you retire, that's fine, but to succeed you'll need to be prepared to move around within the company and if it's a small company, you're already hampered by the dead man's shoes prospect.

If you intend to succeed in business and have a family, then a key factor for many women is whether they can afford really good childcare. It just can't be done if you're relying on friends and family, there's got to be a backup plan, particularly if children are ill and live-in nannies aren't a cheap option. For many working mothers, paying a live-in nanny could mean their entire pay packet disappearing in one go, so it's catch-22; you've got to be earning enough to cover the cost of your childcare and still make it worthwhile. It can be a difficult choice, particularly if you really can't combine

family life with work because of the location and hours. Entrepreneur Martha Lane Fox, a co-founder of lastminute.com, admits that it's a decision she's not yet had to face but says it's the turning point for many women:

> Women have to make difficult choices; particularly in their mid thirties when people are knuckling down to get to board level it's a time when women have to make a choice whether to take a couple of years out and have a family and that can affect their pattern in life.

One area where women can fall down is that with all this multitasking, coping with family life and generally trying to be all things to everyone at the same time, we've no time left for networking. Martha Lane Fox says a key skill that men are very good at is networking and planning their next move upwards:

> They think about their own self-promotion – I notice the men who work for me often spend a lot more time telling you what they're doing yet the women work just as hard but don't build the links up in the organisation and I think that's just down to confidence.

There are now a growing number of women's business networking and support groups across the country. The Women in Management network, founded by Dr Eleanor Macdonald, aims to offer support for those aspiring to move up the management career ladder. The organisation started in London and now has 15 branches across the country, with

members at every level from the self-employed up to chief executive status. Pam Smith has been the national chairman since 2003 and firmly believes that mentoring, tutoring, encouraging and supporting women is the key to getting them further up the ladder:

> A certain amount is inbred but you need to acquire the actual skills of management and that can come with training.

The argument as to whether we should actively seek to recruit more women into the boardroom isn't only evident in the UK. Research by EIRIS, the Ethical Investment Research Service, shows that over half of the leading European companies have no women on their boards. But it's a different situation in Norway, where the Minister of Children and Family Affairs Laila Daavoey created uproar with her proposals to increase the number of women in boardroom positions to 40 per cent in both state- and public-owned companies by 2005. Stephanie Maier from EIRIS believes that this could be seen as positive discrimination and Pam Smith of Women in Management believes that while it's good to aim for more women in high-profile positions, a woman has got to earn the job:

> I think it has to be done on its own merits; any woman should achieve because she's capable of it and on a par with anyone who applied for the job; she must be the best person for the job.

From the Norwegian perspective, Laila Daavoey, the Minister of Children and Family Affairs, believes that:

The balance of power still falls in men's favour, among other factors, because men in leadership positions tend to recruit other men to such positions. The labour market also tends to prefer a male pattern of career when recruiting for leadership positions. A male pattern includes working long hours and not having breaks from working life. Women, on the other side, tend to prefer more normal working hours or working part time for periods in their working life and to have breaks from their work.

Ironically, in Norway, it could be claimed that Norwegian women are better educated than men:

For several years, more women than men have finished a higher education. The problem is not that we don't have qualified women. The problem is to recruit our highly qualified women into leadership positions and make use of their competence.

Look elsewhere in the world and it's a similar story; corporate Canada has few women at boardroom level, according to a recent report in the *Globe and Mail*. Research by the Report on Business looked at over two hundred companies and found that 45 per cent of the largest companies in Canada did not have a single female director. Just one firm, Corus Entertainment Inc., the Canadian media and entertainment company, has equal numbers of men and women on its board. Its Executive Chair Heather Shaw helped to establish the company and has been listed in the *Financial Post*'s 'Power 50' – 50 of the most powerful women in Canada. It seems that Shaw denies having

a target figure for her board but is an ardent believer that if the population of the country is about fifty fifty, then the board should be representative of that. It's a view backed up by Susan Black, the vice-president of Catalyst Canada, a North American research company, which carried out a report into the advancement of women in business. The research showed that although women make up over half the Canadian workforce, that's not representative of their position in the country's boardrooms. Numbers have increased slightly; from less than 10 per cent of boardroom positions being held by women in 2001, the figure is now just over 11 per cent. But, as Susan Black says, when two out of three university students are women, women are the biggest consumers and make up over half the workforce, why aren't there more of them at the top?

Having your board or management team truly representative of your clients or consumers is something Niall FitzGerald of Unilever wholeheartedly supports:

> It is self-evident that we will be better placed to understand and connect with our consumers if our employees and, in particular, the leaders are themselves a reflection of our consumers.

Unilever has 33 nationalities in its top 200 leaders and over 100 nationalities working within the company globally. It clearly makes sense to have your workers and in turn management as representative of your customer base and this is a key area where women come into their own. Stephanie Maier of EIRIS says:

Boards should start looking at recruiting from areas where women are strongly represented. In companies where they've got a large female customer base like some areas of the retail sector it does seem a little ridiculous not to have women on the board.

But if you can't or choose not to climb the corporate ladder, another way to make it into the boardroom is to start your own company. Pam Smith, the national chairman of Women in Management says:

Women nowadays are more confident in themselves and their own abilities. If you go back a number of years many women wouldn't have dared to pack in a job and start their own business; they wouldn't have had sufficient confidence in themselves.

There are numerous examples of women who've started their own business, many, ironically, after having children and then starting a child-oriented business, for example producing allergy-free cakes or making child-friendly T-shirts, while others have used their previous corporate experience to turn a niche in the market into a multimillion-pound business.

Another entrepreneur and now extremely successful business-woman who the media developed a fascination with is Martha Lane Fox. Along with her business partner Brent Hoberman she set up lastminute.com. The company specialises in late deals on flights, holidays and entertainment and operates in 13 countries with around eight million registered users. It started

back in 1998 with just the two of them and now employs over 1000 people. Unlike the corporate ladder which can prove hard to climb, Martha's experience is almost a total role reversal of the issues mentioned earlier. She told me how, despite doing interviews alongside her business partner Brent Hoberman, he was often eradicated from interviews by the time they appeared in print and even obliterated from photos:

> I attracted a lot of attention; Brent and I would sit literally together and have our photo taken for journalists and they would chop his picture out – now why did they do that? Brent's a great looking guy, he's a very charismatic person but they did it because it's more interesting to have a woman in there because there aren't very many of them.

While the media did develop a fascination with Martha and her personal life including, she says, the constant questioning about whether she had a boyfriend, she admits it did generate publicity but as she points out they weren't the kind of questions that would ever be asked of a man. There's no doubt she's been successful but how much of anyone's success is down to hard work or 'being in the right place at the right time'? Lane Fox says:

> It would be extremely churlish of me to say it's been hard because a lot of what's happened has been quite amazing … Ours was a service that really appealed to people and something that you couldn't do before in the real world; the internet really enabled lastminute.com and I think that one of the things with many web companies that were out there

was that they just put dot com on the end of their name and expected everything to be fine; you had to really think about what technology was going to do that was different and I think that's one of the successes of lastminute.com.

Lane Fox readily admits at times there were 'lucky flukes' and that it hasn't all turned out the way it was planned:

I've never had a big grand plan, a lot of what's happened has been complete serendipity and a case of taking opportunities when they presented themselves. I've been phenomenally lucky and had the luxury of having parents that didn't push me into a certain career – that's all helped tremendously.

So how would she describe the 'must have' leadership skills that women need to get to the top?

Charisma, passion, clarity of vision and the ability to communicate but that's not specific to either women or men. I think the great leaders are those who sit with the checkout girl in the supermarket and at lastminute.com they sit with the customer service agents; it's people who don't lose touch with what's really happening in the business but at the same time can step back and give really clear guidance through the whole organisation in a charismatic and passionate way.

Although Lane Fox is now leaving the company she started, she plans to stay on as non-executive director and intends to look for new challenges, possibly going it alone this time.

Maybe an element of having to prove that you really can stand on your own two feet in the harsh world of business?

In some areas of business there may be more of an inherent sexist culture which can take years to break down, so in areas where women are coming up against a very real and hard-hitting glass ceiling there may be no immediate answer to the problem. There's certainly no set path to guarantee unparalleled success in business whether in the corporate world or within your own business. But the chink of light appearing through the cracks in the glass ceiling could be the changing face of business as women become more instrumental to the future success of business in the twenty-first century. Far from taking the business route via the old boy networks, women are using their natural communication skills and talents to get the best from their colleagues and employees and making them feel valued and needed – particularly essential in light of so much insecurity about job prospects in the workplace.

Women have to contend with many obstacles including family, prejudice or envy from colleagues and the system but on a positive level it's now being recognised that women can succeed using their female skills without having to adopt a masculine approach. Unilever's Niall Fitzgerald says:

> I believe it is increasingly important that women should stop feeling they have to be like men to succeed like men. This is going in the wrong direction.

48

chapter 4

HOW WILL
MEN COPE?

Let's talk about men. If men, in the old school mould, are no longer the guaranteed blueprint for business success, as maybe they once were seen to be, what has this done to their ego and self-esteem? How are men coping with the increasing numbers of women in the workplace and those women at management level, now their bosses or contemporaries rather than their employees?

While women have been busy taking chunks out of the glass ceiling, what's been the reaction from men? What effect has the ever shrinking gap between male and female success in the workplace had on the male self-esteem and ego and has it left them searching for a new role? According to some rather cynical researchers, they'd have us believe that men could end up being completely superfluous to women's needs. I remember reading some research a while back which claimed that as women have rapidly become more financially independent in order to support themselves and their families, are physically able to have babies themselves and multitask to a much greater

degree than men, it's now possible for them to take on bringing up a child along with a full-time working role so what need could there be for men in our lives in the future?

I think that's a very cynical extreme and certainly not my view but surely it follows that if one sex changes or maybe starts to redefine its traditional role, of course it will have a knock-on effect on the other gender? Traditionally the 'hunter gatherer', can modern man cope with his changing and some would say eroding role in today's society? Even just taking the workplace as an example, men can often face a potential minefield. You can't afford to be too friendly to your female work colleagues for fear of being accused of sexual harass-ment and in trying to bond with your male colleagues, a few pints in the pub may be frowned on by many companies which take a dim view of colleagues drinking during working hours. On the personal front, men too are also trying to combine work with finding time for a decent family life, and let's not forget the numbers of men who do bring up children single-handedly whether through a relationship break-up or their partner dying. Lastly, as a man you're constantly being bombarded with advice or stories about how to be a 'new man' and finding that your new boss is a woman and you've got to compete not just with your male colleagues for promotion but with your female colleagues too.

Where men and women's roles were once more clearly defined – men went out to work and women stayed home – the lines are now somewhat blurred, with more men, if still a minority, taking on the role of househusband and staying at

home with the children. This may be a decision made out of choice or because, as the lower earning partner, his wage isn't enough to support childcare costs and still bring home a decent wage.

As well as looking at men who opt to stay home and play househusband, we'll also head back into the workplace to find out why some companies are actively training their male employees to learn traditional 'feminine' skills in order to help them perform better at work. If this is the case, then could the fundamental truth be the fact that the skills women possess are actually those that are better honed for business in today's society rather than those of the traditional macho boss, and that men should in fact be following the female style of leadership to succeed in business?

Let's look at how men cope when a woman is the boss. It depends on the industry you're in. Still outnumbered by their female counterparts, the male secretary is not a new concept but interesting that the title is now often that of personal assistant or administrator rather than 'secretary'. Female bosses often say that male assistants are more businesslike and less likely to try and take on a more personal role than women in the same job. But the other way round, maybe the typical male manager likes the personal skills that a woman can bring to the job. I have one friend who several years ago had to collect her boss's dry cleaning and organise his wife's birthday presents! Within other industries, for example the engineering business, it's more likely still to be the male manager at the top. Research carried out by the Management

Centre Europe showed that within these industries it's very much a male macho exclusive culture. So when women get to the top they can be tough. The research quotes Guy Mollet of Volkswagen:

> In my experience, women in managerial positions are more demanding than their male counterparts. They tend to be less tolerant of incompetence, because they usually had to fight quite hard to get their own job. That might be why men are reluctant to work for female bosses!

Could another reason men aren't keen to work for female bosses be that while a male boss might understand that your urgent business meeting on a Friday afternoon meant a slope off to the pub or an extended working lunch, a female boss is likely to be less tolerant as her primary objective is to get the job done as she's got other priorities too? In some countries the long hours culture has meant workers are afraid to be the first to leave their desks, but in many European countries if your car is still in the car park at six at night, it's a sign that you can't do your job properly rather than being seen as committed to your job.

I believe that one way men try to cope with powerful women or those in management positions is to try and demote them to ease their own ego. *Fast Track* magazine carried an interview with Linda Chavez-Thompson, the executive vice-president of AFL-CIO, America's union movement, who recounted a story about how despite having a title in her earlier working career, her male colleagues still seemed to consider her as a secretary.

She recalled how, as the only woman in a room of twenty men, she was frequently asked to take minutes at meetings which she refused. Good on her!

So how do men react when faced with competition from women or being told what to do by female bosses. It seems their instinctive reaction is to attack. Some of the women featured in the report by *Fast Track* magazine claimed they'd been referred to as 'pushy broad' and 'bitch'. It seems that some men can't help but resort to playground tactics when feeling insecure and threatened. I remember working alongside one male presenter who seemed to feel personally threatened by anyone who was remotely good at their job. While he always wanted the best people possible to work with, if they showed any spirit, talent or ambition and didn't fit his perception of their role, they didn't seem to last too long.

Let's look at the one role that has traditionally been considered 'female', that of staying at home and bringing up the family. Women themselves seem to go in cycles with this one; from the days when the majority of women stayed at home to bring up children, then there seemed to be a wave of career women who wanted to 'have it all'. This new breed was epitomised by women like the City superwoman Nicola Horlick but then the trend, if you can call it that, almost seemed to revert once again to women wanting to stay at home with their children and have a decent quality of life but this time round looking for more flexible ways of working to combine parenthood with a career. In a later chapter we'll look at the

way women are creating niches for themselves within the workplace by setting up their own businesses to suit their lifestyle – the ultimate in total flexibility.

There are now an increasing number of men opting to stay at home while their wives or partners go out to work. This may be because it makes more financial sense or because their culture affords them that benefit. Sweden has often led the way when it comes to being a family friendly nation – proposals have even been put forward for parental leave to be divided between a separate allocation for the mother, father and a shared allocation. Around 15 per cent of the total parental leave taken in the country is used by men; not a lot but considerably higher than many other countries.

According to research by HomeDad, a UK-based support group dedicated to helping stay-at-home dads, there were around 155,000 fathers staying at home with their children in 2001 in the UK. A 1995 report by the US Census Bureau revealed that fathers account for just over 16 per cent of stay-at-home parents in families where one parent works in the US. You don't have to look too far to find examples of famous dads like David Beckham, Mel Gibson, Sir Bob Geldof or Madonna's husband Guy Ritchie who are widely admired as role models and seem to spend large amounts of time with their children, in some cases even down to sharing childcare responsibilities.

While women often highlight the glass ceiling as the ultimate stumbling block in the business world, maybe there's also a

glass ceiling of sorts for men to overcome in the stay-at-home game. Whereas women can qualify for maternity leave, parental leave and payments given to fathers has been very slow to catch up. Two stay-at-home dads, Nick Cavender and Simon Windisch, launched HomeDad.org.uk in September 2000. The aim of the website is to bring together stay-at-home dads. Co-founder Nick Cavender first gave up his job in local government around five years ago after the birth of his daughter when his wife returned to her job in IT after finishing maternity leave. Nick says the reason they started HomeDad was because they were concerned about the isolation aspect that came with being out of the workplace, and they felt that some of the traditional outlets for women were pretty much exclusive female territory:

> We wanted to link up with other fathers in the same position as ourselves; we felt that we had no real voice in society.

HomeDad is currently web-based although there are plans to get funding and set up as a charity in the future. Cavender now works part time in the library service, something he readily admits wouldn't have been possible a few years ago and that he'd really never have considered because 'it isn't terribly well paid'. He describes his previous job in local government as being very stressful: 'it was time for me to move on anyway but when I initially thought about taking time out to stay at home it was meant to be a six-month break'. His wife was the main breadwinner, earning more than he did and Nick says the practical element of paying out on two childcare bills was a heavy financial burden:

My wife's career has always been very important to her, she's very driven and when we had children she wanted to return to work but it would have been quite difficult for her to work on a part-time basis if she was to achieve what she wanted in her career.

After weighing up the childcare options – with neither of them having parents nearby – they decided they didn't want a nanny or childminder bringing up their daughter and as Nick was at a crossroads in his career, he gave up his job once his wife's maternity leave ended. From taking an initial six-month period to explore his options and consider other career avenues, five years and another baby later he's still at home and enjoying his new life.

But while staying at home is a role that might work for Cavender and, it would seem, an increasing number of fathers in today's society, what about the view from their peers? Envy, scorn, disbelief from the alpha male population? Cavender says he's experienced the whole range of views from his peers including those who think he's got it easy staying at home: 'they think babies sleep a lot and are happy playing with a shoe box and a stuffed toy for hours'. Somehow reminiscent to my mind of comments made by men when their wives or partners were at home: 'don't you just sit around eating cake, chatting and drinking coffee all day?' was one comment I recall hearing from one friend's partner!

And what about the other aspect of stay-at-home fathers – if a man isn't bringing home the bacon, how does he feel about

having to ask his wife for hand-outs – a subject that I would have thought would make even the most hardened 'new man' feel slightly uncomfortable about? 'We've always had a joint account and pooled all our money', says Nick Cavender:

> I did feel differently about it when I stopped working; I wasn't earning anything and not able to contribute and found that quite hard but we've always had the attitude that we work as a partnership and work for the family and it's recognised that I'm doing the work inside the house. It's definitely easier now that I'm working part time although I probably spend far more than I earn but at least I feel I'm making a contribution.

While this situation might work in some cases, some men do have a greater problem adapting to the change in roles. Cavender knows of cases where relationships have foundered and broken down in this situation but, as he points out, can you ever attribute a relationship breakdown to any one thing? There could of course be other underlying reasons why the relationship went wrong. He says one of the hardest aspects of the role is if you're doing it through circumstance rather than choice:

> I know men who've taken on the role of stay-at-home dad but not of out choice. Take the situation where you've got two children very close together and one of you isn't earning enough to cover the cost of the childcare; if it's the man in that situation he might not be at home by choice and that's a difficult situation. I know a couple of men

who've really struggled with that until the children started school and they could return to work – as they only needed childcare arrangements after school.

So what do the psychologists make of this – they're always telling us that a man's level of self-esteem and sense of self-worth is intrinsically linked with his success at work, so does the role reversal have a more far-reaching or deeper effect on men than is at first apparent? Dr John Nicholson is chairman of Nicholson McBride, the largest independent business psychology group in Europe, with sites in both the UK and US, and has experience working with over one-third of the top 100 companies in the UK. Dr Nicholson says even with families where the father stays at home by mutual agreement:

> there are still some discomforts, embarrassments and diffi-
> culties but on the whole that set-up can and does work and
> can work as well as it does the other way round. It's really
> no worse a prospect if you've got a woman being
> successful and a man playing househusband than the other
> way round.

But if Dr Nicholson is right, then why are we seeing workplace courses aimed at helping men to regain some of their assertiveness and in some cases try to learn some of the traditionally accepted 'female' skills? When the Navigator course, (*Guardian,* 1999), a personal development course for men, designed by the Springboard consultancy in collabora-tion with coaching and mentoring specialist James Traeger, was launched five years ago, it was claimed in the media that

a number of companies were so concerned about male employees losing face in the workplace under increasing competition from female colleagues that this form of self-help assertiveness training course was now necessary. The course is a series of four one-day workshops held over three months, along with coaching, networking opportunities and a personal development workbook. The Navigator Men's Development Programme has been used by over 100 companies throughout the world, including commercial companies, universities and government departments, and over 3000 men worldwide have now done the course. There are 30 Navigator trainers across the UK, Australia and Ireland including James Traeger who was instrumental in designing the course. He says that if you go back to some of the research done in the 1970s and look at the traits associated with men and women, you will find the traits that people associate with positive things are usually the male traits, like leadership and being positive, and the ones they tend to rate less positively are the ones they traditionally relate to women like nurturing or being kind. However, James Traeger says:

> What's happened in the last generation in terms of the management culture is that the traits we associate with women have become increasingly more valuable, things like communication and team building and the ability to negotiate. So if you asked a group of people the good qualities of a manger in the twenty-first century, they'd probably list those skills – the ones that are typically asso-ciated with women. They might balance them with, say, the ability to manage IT or complexity, but if you're talking

complexity you're talking multitasking and you're back with women again. That's where this notion of men supposedly becoming deskilled comes from – because actually the traits that we traditionally associate with masculinity are less in demand in the modern workplace.

He says the Navigator course, in contrast to media perception, is not there to help men to regain their lost male assertiveness skills but is intended more as a way of creating some clarity for men, particularly as the 'traditional model of male masculinity just doesn't help'.

So, on the one hand, if the traditional female skills are now those potentially in demand by employees and men are having to learn 'new' or different skills to succeed in the workplace, where does this leave them? Being forced into playing a more supporting role to their high-flying career wives or partners? I remember reading a very funny and perceptive article about men giving up their careers to support their wives in the *Guardian* newspaper (2002), written by the successful Irish novelist Marian Keyes. She was reciting the story of how her own husband had given up his career to be her manager, dogsbody, PA or whatever title people deemed it appropriate to call him. What struck me was the fact that being referred to as the PA, dogsbody or even Mr Keyes, which isn't his name, didn't seem to phase him, according to his wife's view of events, but could this be down to his own inner confidence as a person, where a weaker man would not have been able to handle it? There are of course many examples of high-profile women whose husbands have taken

on a supporting role; take the Queen, who has even spoken out publicly about the support of her husband the Duke of Edinburgh during their years together, and Sir Denis Thatcher was also ever present in the background during Margaret Thatcher's years in Downing Street. As the Iron Lady herself confessed in 1985 on the tenth anniversary of becoming leader of the Conservative Party: 'I couldn't have done it without Denis'.

But for a man sometimes playing second fiddle to a more successful wife or partner isn't always a recipe for success and there have been many high-profile, Hollywood-style relationships that have failed in cases where the man took on the supporting role without an award in sight. *Titanic* star Kate Winslet's marriage to Jim Threapleton was rumoured to have hit problems when he was increasingly left at home looking after their daughter while her career was on the up and look at Jennifer Lopez who married dancer Cris Judd but filed for divorce less than a year later. That's not to say there weren't other reasons for the relationships to fail but taking on the support role isn't always something men find easy to do.

Maybe another twist of the traditional role reversal is to set up a business where you're both equal partners on paper and in the boardroom. Anita Loewe is the chief executive and one half of the company Venues Unlimited that she runs along with her husband Chris. The company has been going since 1989 and is based in Swindon organising conferences and events. Anita advises being very careful in any partnership even though theirs is a husband and wife one:

Although you're living together you must run the business as a professional company. We look after different areas of the business and if we tried to dabble in the same ones that could be an area where problems might occur.

A perennial problem for many couples who live and work together is that there's a danger you might never really escape from work, going home only to relive the office day which can be a similar story for both parties. Says Anita Loewe:

> You really do have to be very careful because that's the last thing you want to do; coming home to talk about work and that's where we're very strict with ourselves. We don't actually see that much of each other at work; we now employ eighty people and we have very different responsibilities so sometimes a whole day will pass where we don't see each other at all.

One aspect that probably gives them a head start is that they have clearly defined different areas of expertise:

> Chris used to speak at events and was previously in the navy, he then worked in offshore industries and was managing director of a company that was involved in inspecting pipelines. So his background was that of a client perspective whereas mine was from working with Holiday Inn for ten years and was very much from the other side of the hotel and the operation business.

But while that might be great advice and women particularly seem to be able to work as a team, taking advice from within that team rather than feeling the need to always 'manage' or 'control' it, how do men react if they can't head up the team and take on the role of team leader? I think some men need a definite demarcation between themselves and those they see as being lower down the team structure. I personally feel that without the 'power' aspect some, dare I say, insecure men do not cope well in the workplace and those with fragile egos can feel that they're facing 'threats' from numerous sources. It's often said that knowledge is power but is trying to retain 'power' at all costs really the best way for men to retain their status or is it merely an act of desperation?

According to Val Williams, an executive coach from America, who specialises in coaching senior corporate executives and their teams on leadership skills, strategic planning and people development, there's a clear distinction between power and strength. Her clients have included Washington Mutual Bank, Pepsi, Harvard University, AT&T and Nokia and she says in this age of corporate downsizing and managing with fewer resources, the traditional leadership model of 'power' has become less effective and is now being replaced by a model of 'strength'. She says that although these two skills often appear similar and are both used when describing leadership, it's the 'distinction between strength and power that can make the difference between success and failure in our new environment'. Williams claims that 'power' typically suggests something bestowed on you from outside, say, by being promoted and is 'frequently tied to position; being a CEO, a

manager, partner, judge, parent, senator'. She says the concept of power implies what you can do to other people, like hiring and firing or curtailing their freedom. 'Power frequently carries external symbols of itself: large office, big staff, preferential parking or seating'. Williams believes that the leadership model of 'strength' implies something different:

> Strength is internal versus external. Strength is what you have inside, not what any outside agency promoted you to. Strength is not dependent on any position: the concept of strength implies not what you can do to others; but what you can create from your own resources. Where power sometimes motivates people through fear, strength leads people through inspiration. Strength connotes charisma, attractiveness. People more naturally follow a strong person. They are motivated to act by something beyond that person's title.

So while it does seem that men still have the edge over women when it comes to securing the top jobs, it's not a position they can retain for much longer, as the workplace culture changes and businesses realise that women and women's skills are essential for business success in the twenty-first century. I don't personally believe we'll ever see a day when women outnumber men in management roles and who's to say that's what we want either but aiming for equality would be a good start.

chapter 5

WORKPLACE SKILLS

Whatever your profession, just think for a minute about the number of hours you worked last week. Most of us spend more time with our work colleagues during a typical working week than we do with our own families, so it's hardly surprising that relationships and affairs as well as mergers and acquisitions take place both inside and outside the boardroom.

While there's plenty of evidence to show that work is the most likely place to meet your future partner, in today's politically correct society, the social interaction and general office banter in many workplaces is being frozen out. Many employees seem too busy or too afraid to interact with each other for fear of being accused of overstepping the line and being drawn into sexual harassment cases. Workplace bullying, stress-related illnesses and even nervous breakdowns are all becoming more common in today's ruthless work environment, so in many cases there's little time left for socialising or even a quick drink after work down the pub.

Think of your own working environment; how much do you actually know about the person or people who sit alongside or opposite you for eight hours plus each day? Do you dread having to take on projects that involve taking business trips with your work colleagues or even socialising with them? I can certainly remember sitting opposite one producer several years ago at a Christmas party who bemoaned the fact that we had to waste time on such frivolous activities when he could be spending the time more constructively making programmes. I just thought he was a complete misery and while he might have been highly intelligent, to my mind he was severely lacking in the social skills department; something that these days is pretty essential if you want to get on in business. Depending on where you work and your working environment, most of us often spend over half our waking hours from Monday to Friday in the presence of people we could know little or next to nothing about.

According to a recent report from people management experts the Chartered Institute of Personnel and Development (CIPD, 2003) women are now working longer hours than they were five years ago, while the average man's working week has been reduced. The proportion of workers who put in over 48 hours a week has increased from one in ten to one in four over the past five years. The same report shows that a woman's average working week has increased by three and half hours while the average man's working hours have fallen by nearly an hour a week. The underlying picture is that men are still on average working longer hours than women but, based on these figures, how long before that difference is

eroded and both sexes are working for the same amount of time each week?

So for the large percentage of the workforce who are female, is it possible to retain your female skills and succeed in the workplace or do you have to adopt a more male presence and attitude at work? And one of the last workplace taboos – can you still flirt? In this chapter we'll look at how and why the office environment has changed and the skills needed to succeed in the workplace.

So can you still be female in the workplace? 'Flirt coach' Elizabeth Clark runs her own business Rapport Unlimited in Morecambe, Lancashire offering flirt coaching, personal branding and career coaching. Her flirt coaching courses entitled Love Your Client are aimed at companies to show how flirting at work and in everyday life can have a positive effect on the individual and those around them. The results from her courses to date are quite astounding. Clark worked with a firm of estate agents who claimed to have doubled their profits after her advice and intervention and she's since been asked to run flirting courses for employees at one top London department store. She says flirting doesn't have to be sexual but it's a skill that can be learned and used to make others feel good about themselves, which in turn benefits you. 'Look at Mediterranean countries where people are much more tactile, particularly when they greet someone, there's lots of kissing, whereas greeting someone in the UK you're lucky if you get a handshake'. While this may be a typical example of the British 'stiff upper lip' attitude ingrained into our culture, it's

a valid point. Although most of us would be rather shocked to be hauled into the boss's office for a group hug on a Monday morning, something as simple as showing an interest in our colleagues and their lives can have a hugely positive impact on our own wellbeing and that of our work colleagues. Clark says:

> I encourage everyone to flirt with everybody, people of the same sex, people of the opposite sex, apply the same techniques to a lesser or greater degree and that way you get really proficient at it, and you'll know how to read people. You'll know how people are going to react to things and you'll know what's appropriate and what's not.

One leading lady who may not spring to mind when you think of great flirts is the so-called Iron Lady herself, former Prime Minister Margaret Thatcher, now Baroness Thatcher, who interestingly once said:

> It will be years before a woman either leads the Conservative Party or becomes prime minister. I don't see it happening in my time.

Elizabeth Clark cites Thatcher as an example of a brilliant flirt:

> She could turn anyone around, she was absolutely charming. When she's with people she's very tactile, she keeps her voice soft in a one-to-one situation. When you're speaking to someone, only 10 per cent of it is what you

say, 20 per cent is how your voice sounds and 70 per cent is down to your body language. What kind of vibes are you giving off, are you making eye contact, are you leaning into someone when you're talking to them? With Margaret Thatcher she looked like she was interested in people; it wasn't always what she was saying but the way she was with people that made a difference.

Recognising when you've got someone's attention is another important skill:

If they're giving you lots of eye contact, if they're mirroring you, if they're getting into your personal space, if they're starting to talk your language, they're giving you all the signals they're interested.

In some instances flirting can backfire and instead of building relationships and oiling the wheels of workplace, it can have the opposite effect, leaving those on the receiving end even more confused about the situation. This happens most when 'powerful driven women who've perhaps previously neglected their feminine skills in the workplace' suddenly decide that flirting is the way forward. According to Clark:

Men can find it difficult dealing with powerful women who flirt; women find it much harder to soften themselves down than men do. If men have worked with the so-called office battleaxe, they'll have a hard job relating to the powerful boss who's suddenly mellowed.

It's all about doing things gradually, otherwise it will come across as if you've just been on a course and been told to flirt or interact with workplace colleagues and are testing out your new-found skills and enthusiasm on your guinea pig colleagues.

Before we look at the basic workplace skills and how women adopt them to a greater or lesser degree than men, let's look at how it works at the top. Who better to ask than business guru Professor Cary Cooper CBE who has over 30 years' experience examining workplace issues and who has written over 80 books on subjects including how to maintain a healthy work–life balance and overcoming stress. He's currently professor of organisational psychology and health at Lancaster University Management School. He believes that the difference in men and women's management styles has to be recognised otherwise it can cause huge problems within the workplace:

> The male management style is frequently incompatible with the female management style. If men are going to choose a woman for the job, they choose someone who adheres to the male management model which is 100 per cent commitment, long hours, prepared to do anything, travel anywhere, more bottom line driven, less relationship driven and less considerate.

He says the fundamental key difference in the male and female approach to management is that men are much more

into command and control-style management whereas women are more into relationship-style management:

> Men select in their own image, wanting people similar to them, it's a very unconscious process, they're not deliberately discriminating, they're just looking for someone who has a command and control type of attitude, who is prepared to give up everything for work. Women are committed but they also have a life outside work.

The human resources director of the banking giant Abbey is Priscilla Vacassin. She's been in the post since 2003 and at 47 has spent around 20 years in the workplace, having consciously decided to take time out before she started her career to bring up her two children. Vacassin goes along with the theory of many psychologists that:

> Men define themselves more closely to what they do and women define themselves more closely to who they are.

So while a man might tell you within the first five minutes of meeting him what he does for a living, his position within the company, how he got there, where he's going next and his future career path, women are more likely to define themselves in terms of who they are, for example a wife, partner or mother.

So what is the answer to the ongoing problem of how to combine work with family life, an issue particularly pertinent to women. Vacassin was actually doing her finals at university

when she and her husband discovered that they were expecting their first baby. Although she admits she wouldn't have planned to have children first and that starting off in the workplace at 26, was, 'not that easy' as she was nearing the age limit for people taken on under graduate recruitment schemes, she does feel that her life experience and maturity were of great benefit to her first employers, United Biscuits.

It was hard to get in at 26 but I think I was a lot more mature than the average 26-year-old. When you've got no money, children and a house to support, you learn quite a lot and you can transfer those skills to managing people and situations.

After leaving United Biscuits Vacassin worked for Kingfisher and later BAA before joining Abbey. From Vacassin's viewpoint, although she admits she wouldn't have planned to have her family first, it meant that she didn't endure the problems many women face when they have to make a decision about starting a family part way through their career or realise they can't cope with the commitment that a full-time job and motherhood entails.

Professor Cooper says women just can't put in the long hours sometimes needed for success because they're managing family life, often without much help or support from their partners:

If women are trying to push the glass ceiling up and see that it's a slow process and they're also trying to juggle a

home–work–life balance, then a number of them are deciding they can't be bothered to wait and leaving.

But far from being seen as detrimental to their career, Cooper says this could in fact be very positive because many of them go on to start their own businesses:

> They're beginning to say if I have no control in the corporates why don't I take the skills I've got and do what I want when I want and start a small business.

Professor Cooper's comments are borne out by UK government statistics: the number of people becoming self-employed increased dramatically in the year to September 2003, bucking a decade-long trend with hardly any growth. The total figures increased by nearly 9 per cent, around 282,000 people. This accounts almost entirely for the current increase in total UK employment, as the number of employees increased by only 9000 during the year. Women account for 29 per cent of the new self-employed, nearly a third, that's 82,000 people, with over half of those women choosing to work part time.

Fiona Bruce is an inspiring example of a successful businesswoman who gave up her employee status to start her own law firm to fulfil her vision of a different work culture. Before she reached 30, Fiona had all the trappings of success as a partner within a Manchester law firm – new BMW, city flat, country cottage and decent pay packet – but then decided to leave and start up her own business, Fiona Bruce & Co. Solicitors in

Warrington, 15 years ago. She now employs around 30 staff including 12 solicitors. Fiona is married with two young children and was the UK national winner of the Small Business Bureau's 2003 Women In Business Award. She was also voted *She* magazine's Most Inspiring Businesswoman by the magazine readers in November 2003. She has also been selected as the parliamentary prospective candidate for the Conservative Party for Warrington South.

In the early days of starting her business, she ended up making telephone calls from a local phone box with a pile of ten pence pieces beside her and for a time ran the firm while bedridden in the flat above her office after being involved in a head-on car crash where she'd been a passenger. Fiona has worked hard for her achievements, although she says she's not proud to admit she only took four days off for the birth of her first baby: 'I had my baby on Maundy Thursday before Easter and at nine on the following Wednesday was back at my desk in full-time work.' The reason for this speedy return to work was for fear of losing both clients and business.

She says far from having a negative effect on her career, the skills involved in being a mother actively enhanced her career:

> Mothers make great managers; the qualities that a mother can bring to the workplace are totally underestimated by society. Being a mother made me a better manager as I started thinking laterally. One of the most important things I can do with my staff is to sit and listen, I'm not being patro-

nising, but they want to talk to me, they want me to listen and understand where they're at and that affirmation is what we all need.

The skills learnt during parenthood are now being recognised by the big multinational companies. Remember how I mentioned that Unilever had introduced a Mum's CV in the chapter on boardroom skills? Seems parenting skills now have their place in the work culture. Fiona cites an example of a colleague who joined her practice after ten years of bringing up her children:

> She's brought so much to the job, she specialises in conveyancing and there's so much she can offer in terms of understanding and life experience that a trainee straight from college couldn't. She understands the stresses and strains of everyday life.

The advances in technology require new skills which can of course be learnt but you can't take a crash course in life experience or get a degree in it; small wonder the mythical 'university of life' is often cited as a valuable alternative to paper qualifications.

With three women lawyers and one male solicitor on flexible working arrangements at her own instigation, Bruce says it's amazing how much people who are used to spending most of their life juggling family and work commitments can pack into the average working day: 'They're used to juggling so they're good time managers'.

As a working mum herself, she places great emphasis on family life and life outside work and enjoying work:

> At the end of your life you're not going to measure your fulfilment by whether you drove a Range Rover for three years, you'll think what did I contribute, what difference did I make and what relationships have I built?

Let's take a look at the basic key workplace skills that are essential for success whether you're male or female. Confidence and communication really go hand in hand when it comes to putting yourself across in the best possible light. Human resources director of Abbey Priscilla Vacassin says that men experience less attacks of confidence than women and women should learn to be more decisive:

> Stop questioning yourself. Once a decision is made men benefit from being more decisive and seeing it through whereas women may stop at each stage and review their decision which can lead people to question their competence. If you see someone who looks very confident in what they do it inspires confidence.

Professor Cary Cooper cites women's' good communication skills as the main reason that the glass ceiling is being pushed upwards. He says that women have better interpersonal skills than men and are better at both team building and building relationships, skills that are now more useful than ever before because of the way the work culture is changing:

Men may be good at the technical aspect of the job and are more decisive and bottom line but there are so many changes taking place in the workplace that to manage people's resistance to change and fears of change is becoming a very high priority and women are much better at that. If you're constantly merging, acquiring, restructuring, downsizing, introducing new technology, constantly changing at a speed much faster than 20 years ago, that change requires someone to manage the change and in my opinion women are much better at that.

He strongly believes that despite the fact that around only 9 per cent of top management positions are currently filled by women, because of this slowly changing work culture it is in fact women in the future who will be doing the more strategic roles like chief executive.

Basic communication skills are essential in any work environment, so scuttling across the office trying not to be noticed will achieve just that and you'll be passed over for promotion. 'Eye contact is vital, smiling, people react very positively to smiles', says Rapport Unlimited's Elizabeth Clark:

You don't have to go round grinning like a Cheshire cat but look happy. When you're dealing with people your face should be animated; be positive, nothing is more unattractive than people who put themselves down or find it hard to accept compliments.

She says the golden rule is to remember that 70 per cent of the way you come across is to do with body language and of that 40 per cent is in your face, so that eye contact and gestures like leaning forward when you're trying to make a point are all vital: 'Politicians are very well honed in that respect, watch them on TV and they always lean in when making their point.' While striving to brush up on your communication skills, you've still got to be aware of the whole issue of personal space. If you've ever been on a crowded train, you'll know how uncomfortable it can be being crushed next to someone in much closer proximity than you'd expect in everyday life. Body language experts believe we have several layers of personal space boundaries, an intimate zone for people you are very comfortable with, typically about eighteen inches from your body, your social zone for colleagues and acquaintances and then strangers who are even further beyond these areas. These boundaries are often less in other countries, according to Clark, for example in the Netherlands, 'their personal space is much smaller than ours, when they speak to you they'll stand right next to you to talk to you'.

While the long hours work culture can't be overturned overnight, many believe it's essential that the boss sets the example here. Fiona Bruce likens employees to children, in the sense that:

> It's not what you say but what you do that counts. If you leave to go home to your own family, you're giving out the

message that family matters so others should follow that lead and go home themselves to spend time with their families.

She also believes that we need to learn to measure success based on delivery rather than physical time constraints. If employees feel there's a degree of flexibility, in that as long as the job's done and done properly they can leave half an hour earlier when necessary without risking the wrath of the boss, that's a positive step.

As a freelance broadcaster and journalist, luckily I've not had to endure a workplace regime where I've got to sit at my desk from nine to five and leave not a minute before. If I'm asked to present a programme, then yes, within reason, it's my choice if I want to turn up two hours before and do some preparation, read my research notes and go through the papers. I'm being paid to do a job and while turning up just five minutes before a live show would probably guarantee the producer a heart attack, although in theory if you pull off a potential award-winning show you might just get away with it, I doubt that the rest of the team, however, would thank you for the unnecessary stress factor and rise in blood pressure! What I'm trying to illustrate is that surely your performance in the workplace should be attributed to your achievement rather than physical presence in the workplace.

Of course there are far too many jobs and roles within the world's labour markets to mention here. We've already looked at how the workplace culture is changing and for many people work hours are flexible or may involve corporate entertaining

or visiting clients outside office hours. While jobs within the media, advertising and the armed forces are just some of the areas where you can work long or unusual shift patterns, it's worth looking at how the traditional workplace skills need to be adapted when you're enduring long periods with colleagues, often outside the traditional barriers of the workplace.

One of the most extreme jobs in terms of locations and also work culture has to be the conditions endured by members of the British Antarctic Survey (BAS), who often work away from home for up to four months. Anna Jones is 38 and an atmospheric chemist who's worked with BAS for 12 years. Her job involves studying the chemistry of the lower atmosphere over Antarctica and she's worked in Antarctica for two summer seasons for around six to seven weeks each time. She says it was an advantage in that situation to be thrown in at the deep end with work colleagues who she didn't really know well before the expedition:

> I wasn't going south with people I worked with in the office, I went with people I didn't really know which I liked because I think you're working under very different circumstances and totally different pressures and people react in different ways and that brings out the more human side of people which isn't always what you'd see on a day-to-day basis and then when you come back again you have to readjust, so it's a little bit schizophrenic for the people there but personally I'd rather go there not knowing anybody.

Jones says the skills needed to do the job are pretty much the same as in any workplace:

> You've got to think clearly about what you want, the goals and maintain good communication with the people you're working with. Part of one of the projects was to arrange and design the build of a laboratory which involved a lot of work with technical services which really was tiptoeing into the male domain.

Her ethos was to talk to people:

> I do talk to people a lot, I communicate as I go and I think there was probably more communication than they would normally have had if there was a man running the project.

Jones says she prefers the face-to-face approach because of the immediate response and says she attaches great importance to showing appreciation to the team, 'and saying thank you when they've completed a project'. This may seem a small example but Jones says that with more women now working at BAS, particularly in positions of management, there's one sure-fire way to open the channels of communication:

> One of my colleagues has instigated regular meetings where we now have coffee and biscuits and the communication has improved dramatically – it means things work a lot better.

There are other areas we haven't mentioned where women can and do excel in the workplace. Company boss Fiona Bruce says that whereas men have a very hierarchical and traditional view of management, women are prepared to leave their ego outside the office and ask their staff for ideas and views on how to make projects work. And there's the whole issue of people having more respect for a boss who's really been prepared to get their hands dirty when it's a case of all hands to the deck. The example of Fiona Bruce's legal firm comes to mind. In the early days of setting up her practice, the bulk of her work came from the property market. When the severe recession hit the property market, the only way to keep her business going was to work all hours of the day and night, literally from five in the morning until eleven at night.

So when it comes to the new face of today's workplace culture, who's going to succeed in the new climate? Workplace guru Professor Cary Cooper sums it up:

> Men like people in big offices, they like to call meetings, they like little empires and they're not as good at communication skills as women, so the future is women.

chapter 6

WOMEN IN THE HEART OF THE CITY: THE MONEY MARKETS

While the Queen has had her head on the country's coinage for years, it's taken the rest of us women a while to catch up. Within the traditional male preserve of the world's money markets, women weren't even supposed to be seen, never mind heard! The London Stock Exchange didn't even allow women in until 1973.

But while we've already seen that women can and do frequently compete on a level playing field with men at work and, according to some experts, as we discovered in the workplace chapter, are actively excelling in some areas of management, then why not in the predominantly male domain of the money markets?

Stock markets, dealing rooms and trading floors were once a form of the old boys club but now are not unfamiliar territory

for women. Times have changed and thankfully pretty quickly in recent times. Can you really believe it was only as recently as 1973 that the London Stock Exchange allowed women in for the first time in its 200 year history?

That may have been a turning point for women but even then life in the City for women has on occasions been fuelled with complaints of unequal pay, bullying, discrimination and limited promotion prospects, with family unfriendly working hours, so you might wonder why any of us girls would opt for that lifestyle?

Nearly thirty years after the London Stock Exchange first opened its doors to women, it finally appointed its own 'first lady' Mrs Clara Furse in the role of chief executive. Mrs Furse's appointment in January 2001 attracted many column inches because, if the rumours were to be believed, the previous three chief executives had been forced to leave. Amazingly, those column inches were apparently not first and foremost because she was a woman – surely a first in itself. As Martha Lane Fox, co-founder of the very successful Lastminute.com, discovered, a lot of the relentless press attention focused in her direction was because she was female, even to the extent that her male colleague and company co-founder was cut out of pictures and interviews that they'd done together.

Maybe one crucial factor that Mrs Furse had going for her was that she actually was eminently well-qualified for the job, having notched up an impressive 21 years' experience in the

finance industry. She had been deputy chairman of LIFFE, the London International Financial Futures Exchange, and before that she'd worked for 15 years at UBS, ending up as a managing director.

But while her appointment might be a first in the UK, it's not just in the City of London that there are powerful women on the financial scene. In the Middle East, Israel has it's own Iron Lady in the form of Galia Maor, who was named as the thirty-fourth most influential woman in the world, according to *Fortune* magazine. As president of Bank Leumi, Israel's second biggest bank, for nearly ten years, she's been a force to be reckoned with and seen some pretty turbulent times. She's seen shares in the bank tumble by nearly 40 per cent at one point and faced Israel's worst recession for 50 years.

While these are examples of women who've made it to the top of the financial industry in two very different countries, let's start at the other end of the scale and look at who holds the purse strings and controls the finances in most family households. In my experience it's often the women; generally we're the ones who know what's coming in and going out; whether there's enough to pay the bills and how much a loaf of bread costs. And aren't we the world's best when it comes to hiding that fantastic new pair of shoes and then later claiming they were a sale bargain when it fact they're Jimmy Choo sandals costing a small fortune? Maybe this goes to show we're just better at the game of manipulation than money but I'm sure you get my drift. But maybe you can have all the designer shoes you want, because according to

research in the UK and the US, women have been proven to be better investors than men. I'm not talking about squirrelling away your hard-earned cash for a rainy day, but put a woman in charge of a stock market fund and according to research she'll make a greater success of it than a man! We'll also find out later in the chapter how women can actually make better financial advisers than men too.

Here's where I think it gets really interesting; down to the nuts and bolts so to speak. Some of the research I'm referring to came from Digital Look, a web-based share and financial company that carried out research into private investors in the UK. In a nutshell it showed that the performance of shares owned by women significantly outperformed the shares owned by men and also women's share portfolios outperformed the growth of the London Stock Market! The research looked at the performance of shares during the first eleven months of 2002, a period in which the FTSE 100 index of leading shares fell 20 per cent. During that time the female investors saw their share portfolios fall by just 4 per cent while the average fall for the private male investor was 19 per cent. How did they do it? Well, in general, the research showed that the women had tended to back the safer and less risky stocks, for example the blue-chip companies while the men proved to be greater risk takers and weren't adverse to 'having a flutter' and backing the higher risk options. Some may want to argue that this is just down to beginners luck and the unpredictability of the stock market, but it's the same story for the early part of 2003. The women investors beat not only the men but the

FTSE 100 index again. The female investors averaged a loss of just 4 per cent in the first three months of 2003 compared with a fall of double that figure in the FTSE 100 index; down 8 per cent over the same period. This time round the men suffered an average 9 per cent fall in the value of their portfolios.

Andy Yates, the director of Digital Look, says the results have certainly raised some eyebrows in the traditionally male dominated city:

> Over the last few years women have comfortably outper-formed men when it comes to share investing – and that trend is set to continue.

It would seem that both these successes are based on the fact that women have in general stuck to the safer shares (if there is such a thing in the stock market), so let's take a look at how the sexes match up when it comes to investment. According to Digital Look, men tend to invest in riskier stocks in the hope of a quick return on their money and concentrate their portfolios on fewer shares. Their portfolios during the research typically were dominated by telecom stocks like Vodafone, British Telecom, Marconi and Cable & Wireless and they have borne the brunt of share price tumbles around the world. Men, it would seem, have paid the price of backing riskier, smaller stocks and investing in the dot com companies for whom the bubble has now burst. Women, however, avoided large invest-ments in individual companies and their portfolios are

characterised by the FTSE 100 stocks with big high street names that have proved more resilient to the market downturn.

Now if you're thinking that Digital Look's research was just a one off and the men were just unlucky because it was the dot com era and when the bubble burst they paid the price for the gungho attitude, here are some more facts for you from the US. Some interesting research was carried out at Babson College into whether your sex does actually play any part in your ability to manage stock market funds. Richard Bliss and Mark Potter, two professors at Babson, carried out research a couple of years ago into whether sex played a part in fund performance when it came to investment on the world's stock markets. In the past all manner of research had been done into how age or education affected your ability to come out a winner in the stock market but nothing had looked at gender difference. According to the report, the number of female fund managers in the US at the time had grown to 11 per cent; although still a long way off an equal footing with men and women, that figure had doubled over the previous five years. While there had been previous evidence to suggest that women were better investors than men, it was hard to prove because of the small percentage of women fund managers. From the research it seems that women control a significant portion of the investment assets in the US. More than 40 per cent of the households in the US with assets greater than $600,000 are headed by women.

But as well as looking at huge multimillion-dollar funds, let's look at how women fare managing money on a smaller scale

with individual investment groups? Investment clubs where friends, colleagues or neighbours get together to have a flutter on the stock market and buy and sell shares are increasingly popular both in the UK and the US. The National Association Of Investors Corporation, a trade group for investment clubs, saw its membership rise by over 100 per cent in the 1990s and currently over 60 per cent of its clubs are all-women clubs – a huge rise from just 10 per cent in 1984.

One all-female investment club that attracted the headlines and inspired the conception of investment clubs the world over was the Beardstown Ladies as they were known, who started their group in 1983. A group of matrons living in Beardstown, a small farming community near the Illinois River in the US, they formed an investment club and began contributing $25 a month to learn the basics of investment. They had great success and went on to be interviewed and became almost cult figures for the investment club industry. A ten-year study by the National Association of Investors Corporation in the US found that all-female investment clubs have turned in annual returns of 24 per cent on average compared to 19 per cent by male clubs. Surely time to celebrate, girls? It's confirmed what we always knew, we're better with money than the boys!

The Aurora group based in London was set up to support female entrepreneurs and promote women's financial independence and education. Julie Ralston is the Aurora group's women's investment club coordinator, with ten years' experience in investment clubs.

Even from her experience within her own investment club, she says there seem to be clear areas in finance where women and men excel:

> It's the women who come to the group having done extensive research on potential companies for investment. They've always done quite a lot of research, looked at the management structure, the financial sheets, what's happening in the product area or the industry sector. I can't remember any guys doing that – they come with a much more gut reaction type thing, they would read around the subject but present much more verbally than the women and concentrate much more on the finance side. I've felt that the guys recommended the more speculative shares, whereas the women tended to recommend the more stable blue-chip companies.

She claims that although women retain an element of enthusiasm and excitement when looking to invest, it's the men who continue to maintain the 'bull in a china shop' image, with their 'gut feeling' on investments. And it's the men who tend to come up with the more interesting proposals for share investment in potentially maverick or higher risk companies, whereas the women tend to go for safer stock, surprise surprise, a lot of blue-chip companies.

So if women are generally better investors than men and armed with financial knowledge and qualifications, how easy is it to impart that information to others? Do you have to be suited and booted in the traditional pinstripe city suit before

people will take you seriously? Luckily not, although some aspects of the media seem to think so. I've lost count of the number of times I've watched TV and seen middle-aged men giving financial advice dressed in city boy suits; I'm not suggesting they should be wearing their old jeans for the occasion on live TV but it's almost as if they're trying to aspire to a very old and outdated traditional image of being serious about finance.

Who better to ask than Fiona Price, one of the pioneers of financial advice for women? In 1988 Fiona set up her own company of independent financial and tax advisers, Fiona Price and Partners, and she is now the director of Destini Fiona Price and also the founder and chairperson of the Women's IFA (independent financial adviser) Group (WIG). In an industry where there are around 35,000 male independent financial advisers, just 3000 – less than 5 per cent – are women. She says women financial experts in the media are less likely to adhere to the old school style of suited and booted because, as a breed, female financial advisers are a relatively new phenomenon:

> They don't have the baggage to carry around, although if they've been in the industry for 20 years or so they may have had to conform to the 'men in women's clothing' concept.

Fiona made a name for herself with her all-female team giving financial advice to professional and businesswomen but around 20 per cent of her clients are men. She says she hasn't worn suits for years:

Business is about making a difference to people's lives and sitting there suited and booted creates a barrier.

Fiona's pretty much single-handedly responsible for turning the old school of financial advice on its head within the IFA industry. She's been described as the 'first lady of finance' by *Harpers & Queen* magazine and her company is now one of the most high-profile financial advisers in the UK. As someone who's been interviewed numerous times on radio, TV and in magazines, yet claimed to have been 'crap at maths at school' because she didn't like her maths teacher, Fiona believes that there's a huge difference in the way men and women approach finance and numeracy:

Women generally lack confidence which can, I believe, be traced back to social conditioning in the form of 'being taken care of' and looked after.

But according to research carried out by her company into the peer group perception of men and women:

Women are more holistic, ethical, very client focused, they'll agonise over what to do for their clients and aren't overly focused on the money side of things.

Now that might seem an odd thing to say, not overly focused on money in a chapter all about women working in the money markets, but once again it goes back to women looking longer term, looking at the big picture rather than just the short term; the here and now style of thinking that many men adhere to.

Fiona agrees that money is important of course but says it's not the sole focus for a woman; the main focus for a woman adviser tends to be how they can help their clients. Using this theory, you can see why women will continue to succeed as financial advisers, because let's face it nobody likes to be 'sold to' and one of the first rules of selling is that you don't actively let your client know they're being sold to. The general idea is that you've got to make them want the product, you've got to make them see how it will help them, benefit them, enrich their life, with the result that persuasion and trust – rather than the hard sell – do the job.

Further research revealed that both men and women considered men were more target-oriented than women; in my opinion probably because they're brought up to be competitive and to win. On a smaller scale, you try playing competitive games like Monopoly with men. Many years ago I played a game with a mixed group of friends and one of the men, who, incidentally, worked for a finance company, was virtually bankrupt by the end. He wasn't happy to say the least and despite the fact 'it's only a game', his ego was severely dented because he didn't come out on top.

Another key area where women come out on top in the financial adviser field, according to Fiona Price, is that women have a much stronger need to gain the top qualifications. She says she's known many women who have voluntarily sat exams to gain the highest qualifications they can within the sector. It's easy to understand where that aspect comes from; it can be argued that women still feel the need to prove them-

selves because they're competing in what's traditionally been seen as a man's world, which means you've got more motivation to be knowledgeable.

But let's not forget that the whole issue of finance is one where many people feel out of their depth, so in giving people financial advice you're having to build and establish a great level of trust with them, possibly over a lifetime. So when it comes to the finance industry, are women more trustworthy than men? If you were handing over your hard-earned cash to invest, would you rather give it to a man or woman? That may be down to nothing more than personal preference or, as we discovered in the workplace chapter, is it in fact down to women's natural 'people' skills? Fiona Price says:

> Women do tend to take a longer term view; because it's in their genes, in their social world as mother and wife and they're looking for the long-term security of their family so it's something cultural that makes women long termers.

Couple that with the holistic approach that she believes women have and the difference between the traditional, figure-focused, short-term-planning male adviser becomes very apparent. It could be argued that giving financial advice is one job that women are ideal for; not only is there a huge element of flexibility in that you can work according to different pay structures, with salaried or bonus-led pay, but also with part-time or other more flexible working arrangements.

Could women be the salvation of the badly tarnished financial services industry, battered after the mis-selling of pensions and the mortgage endowment fiascos? Yvonne Goodwin, an independent financial adviser from Pearson Jones and winner of the IFA Woman of the Year Award 2003, backs up a theory raised by Fiona Bruce, who runs her own legal practice in Warrington and who featured in the earlier chapter on workplace skills. Goodwin claims that it's the fact that women's leadership style is 'inclusive and not egocentric' which actually helps to get people working alongside each other. The industry has emerged somewhat bruised after recent years, with the pensions' mis-selling scandals and many homeowners facing mortgage deficits after endowment policies were sold at a rate of knots back in the 1980s.

Goodwin believes that:

> By getting more women into client-facing roles, the tarnished image of the sector will begin to improve. The public will gradually begin to trust financial advisers again and this has got to be good for everyone. Also, because women are long-term thinkers and strategists this will help to create sustainable businesses.

On the occasions when I've had dealings with financial advisers, they've all been men and all very much of the old school where they 'told' me what to do rather than discussed it. Fair enough, I was 15 years younger then and just starting out with my first house and pension, but the message coming

across seemed to be that they held the knowledge and the power, rather than taking on a guiding role or giving me any feeling that we were on an equal footing which I believe women can achieve because of a lack of visible ego. I'm not saying women don't have egos, we do, but I believe we're able to keep them hidden when the situation depends on it.

One area in the financial sector where, in my own experience, I've never come across any sexism, prejudice or glass ceilings to bang your head against was during my time as a reporter for BBC business programmes. There was a pretty equal mix of male and female reporters, both staff and freelancers, and as a woman you certainly didn't get the 'girlie' soft stories! In fact sport has never been my strong point, particularly football, and I can remember my heart sinking on one occasion when I was once assigned a business report for the *Financial World Tonight* on that very subject. But somehow I learnt enough in a day from the wonderfully knowledgeable people I'd interviewed and my colleagues to make a three-minute report for the evening programme.

In ending this chapter, I think it's important to mention that while ambition drives some women to seek success in a work environment, there will be others who just have no interest or desire for that. Thank goodness really, otherwise we'll all be competing to be the chief executive of the London Stock Exchange. I think it's important to remember that sometimes the lack of women in certain positions or industries is down to nothing more than the majority of them aren't interested in those roles or have other priorities like raising a family. So

rather than criticise the lack of women in the money markets believing it's all down to some form of sexism, shouldn't we actually be asking ourselves whether in general those areas are ones where the majority of women actually *want* to work?

Equally, in other areas of finance it seems that women could be the industry's salvation. 'It's all part of feminising the business world,' believes Fiona Price:

> I don't mean that in any sense of neutering – but equalising the balance of male and female approach because if you look at the short term which is where the hard sell and patronising aspect is very male and it hasn't worked, just look at the mess we're in.

chapter 7

SISTERS ARE DOING IT FOR THEMSELVES

This is not going to be some sort of feminist chapter but I thought it was important to highlight some examples of real women who'd made it happen by themselves. I wanted to find out how easy or hard it had been for them and whether they thought there was much in the way of support out there for women in the form of organisations, networking groups and recognition through awards.

I also felt that somewhere in this book there needed to be a chapter that looked at female survival instincts and how, when the going gets tough, it's women who can get up and get going. I believe it's an inherent female ability to get back up when the chips are well and truly down and life's dealt you a huge smack in the face. Most women seem to have an amazing ability to pick themselves up, dust themselves off and give life another go.

According to the psychologists, and there are more studies and surveys on this area than you could probably read during your lifetime, in general men seem to fare better physically and emotionally in marriage and long-term relationships than on their own, whereas women often seem to use a relationship break-up as a springboard to another facet of their life; maybe a new career or option for travelling or starting their own business. It seems to me, having spoken to many women in the process of researching this book, that somehow it's often only by themselves that some women are capable of really showing their true strength of character.

Another aspect I wanted to look at was the level of support that women tend to give each other. Of course, you'll always meet exceptions to the rule, but I'm a great believer in the fact that women will often try and help each other out, not only on a personal level but in a business environment too. I'm not suggesting that we're all too sickly sweet for our own good and would show the job description you've set your heart on to your office colleagues and encourage them to apply too, but when it comes to seeking advice from women, I think we're a lot more receptive than men would be if asked to help out their male counterparts. Fear of competition, even the fear of asking for help in case it's construed as a weakness, would be instant barriers in the path to asking for advice.

I want to highlight a couple of what I consider to be really inspirational stories; both about women who have successfully turned their lives around after experiencing traumatic events in their lives. Sally Preston went through an acrimonious divorce

while bringing up her two young children, and then developed skin cancer before setting up her award-winning baby food business, Babylicious, two years ago. Prior to setting up the business, she'd been working in a corporate career at Marks & Spencer as a food scientist. 'Life had been really crap and if you're not doing something you're enjoying then there really isn't much point' she told me.

Sally had thought of her idea for Babylicious two years previously; the concept was to produce home-made baby food and store it in specially produced trays similar to those used for ice cubes. She'd temporarily shelved the original idea but after talking it over with her partner Tony, he gave her the encouragement she needed. 'He basically told me to "go for it", he said "I believe in you", my family and friends believed in me and you can't underestimate the power of family and friends, you really can't'. After all she'd been through, Sally says it was the 'realisation that life's not a rehearsal' that made her determined to give it a go. She's a firm believer in taking opportunities when they arise and not listening to negative views, thoughts and opinions of friends.

Babylicious is now stocked in supermarkets nationwide and is expected to make a two million pound turnover this year. The company is currently researching overseas markets including the US and France, has won a string of awards including the HSBC Start-up Stars Award worth £20,000 and achieved some high-profile publicity including claims that celebrity mothers, like Victoria Beckham, have fed their children on Babylicious.

Despite her success, Preston says she's been quite amazed by the lack of support available:

Allegedly there's funding and grants out there but I know companies who employ people full time just to access that funding and that's crazy.

Even if you can access information, funding, advice and support, maybe it's not all it's cracked up to be as there's still no sure-fire way to ensure the success of your business. Penny Streeter is a mother of four children and the founder and managing director of the recruitment agency Ambition 24 Hours, which specialises in supplying healthcare professionals. With an annual turnover of around sixty million pounds, she was also the winner of the CBI Entrepreneur of the Year award in 2003 but life wasn't always this good. Born in Rhodesia, now Zimbabwe, Streeter went to school in South Africa and set up her first business, a secretarial recruitment agency in the UK. She took advice from everyone that would offer it:

During the 1980s it was very much the culture to start your own business, enterprise agencies were everywhere and there was a queue of people ready to give you advice. We sat there and formed this fantastic company, spent a lot of money doing it and had everything perfect and it just went so horribly wrong.

The recession kicked in, the company went down, Penny's marriage fell apart and she found herself living in homeless

accommodation with her children. It was at this point, when she was at her lowest ebb, that she says the only way was up:

> I suppose it's a bit like being an alcoholic reaching rock bottom. At that point in time I had my children and decided that I wanted so much more for them and no way were we going to grow up in a benefits society-type situation – it was pure determination that took hold. If I go back to those days I'm still in contact with quite a few people that used to live around me and their lives haven't changed but I'm a firm believer that if you take hold of something and you've got the determination to do it you can do it, although people tell me that's not true.

Where the experience might have put some women off, Penny was determined to do it all again but this time round without asking for everyone's advice. She now runs her multimillion-pound business which she started in her friend's office. After discovering a gap in the market for supplying healthcare professionals, Streeter decided to specialise in supplying care assistants and qualified nurses and worked round the clock, with her mother pitching in to help with the childcare, to make it work.

When it comes to taking advice, I think this is one area, as I've mentioned before in the book, where women don't seem to have an ego or problem with it compared with men. Sally Preston of Babylicious says it's natural that when you tell people about an idea or concept, they'll want to add their bit, 'my view is that everyone's contribution is valuable and you

don't have to take any notice of it but often there might be a good idea in there; maybe not in the way it's been presented to you but you can adapt it.'

But it's the hard graft and long hours combined with caring for the children that women like Sally Preston and Penny Streeter don't seem to be afraid of. 'It's got better in the last two months', says Preston:

> I've now employed a group of people to try and build the business so I've got a bit more time to myself, but I was still here at seven-thirty this morning doing emails.

To top that she's doing what women do best, multitasking, picking up the children from school and working weekends and late nights to catch up when she can't be in the office.

Let's look for a minute at what drives women like Sally Preston and Penny Streeter to go all out to succeed. I believe it's that intrinsic female inner strength combined with grit and determination that, when the odds are stacked against you, make you work ever harder to make it happen. With regard to the time she was going through her divorce, Sally Preston says:

> I had to get myself out of bed every day because I had two small children who were then two and four, I didn't have time to lie around and lament how crap it all was. When you're the primary carer you just have to get on with it, you don't have a choice. I had several days where I might have wanted to stay in bed all day and cry but that's not an option.

This chapter is also about looking at doing things from a female perspective – doing things our own way. One reason that a lot of women who've tired of corporate life consider starting their own businesses is to have the chance to put their own ideas and methods of how to run a company into practice. 'I think women are more likely to listen and assess everyone's contributions and not bulldoze their way in', says Sally Preston of Babylicious. She continues:

> I don't really ever play the gender card because I've known some awful women bosses, who were just little cows really. I think it's more to do with your personality rather than your gender. If you're clear and focused and prepared to listen to people's contributions, then you're more likely to get the most out of people. I think people who are insecure and like the power surge are the ones who are not very nice to work for, regardless of whether they're male or female.

I'd agree with that. Certainly in my experience, I think the desire for power and control is a sign of great insecurity. I can remember working alongside one man who got quite panicky at the mere suggestion that any of his team might be taking time off for a holiday. It got to the stage where one producer suggested that nobody even told him in advance of any holiday plans but to just announce it as they were going out of the door on the Friday afternoon! Surely one important skill in life is the ability to adapt to change and changing circum-stances? If you never step outside your comfort zone for a minute, you're never going to benefit from new experiences or other potential opportunities.

Team building, nurturing talent and listening to the ideas and contributions of others are all-important issues on a woman's management agenda but often it seems in the corporate world they can fall by the wayside. Sally Preston previously worked in corporate land, working part time with two small children,

I did feel it was a choice between part-time work or having a career. Children are a bit of a leveller; it makes you put things into context and I think some of the things that people get very excited about in large corporate organisations aren't really that important in the bigger picture and I felt it was time for me to leave. I've never done corporate particularly well, I don't play politics and I don't play silly games, I just think they're such a wasted amount of effort. People in corporate land don't listen to other people but when I left after eleven years it had helped me build a fantastic foundation for me to use the skills I'd learnt having watched good managers and tried to emulate them.

While it seems that many woman are not adverse to giving fellow women a hand up, on the other hand:

in corporate land I think there are some dreadful women bosses who climb the ladder and pull it up behind them. But I think when you're in your own small business environment there are a lot of small business owners who are willing to help others. I've had a lot of help from women but the key thing there is women ask for help, men don't. Women are more likely to say 'come on girls I haven't got a clue about this, what do you think?', whereas men would

blag it and bluff it because they see asking as a sign of weakness. I've had a lot of help from small businesses simply because I've asked.

I don't know if this next little episode should come under the tongue in cheek title of 'help from men' or just really highlights how the traditional sexist attitude of some men is sadly still alive and kicking when it comes to helping women to get on.

Penny Streeter explained to me the background as to why she never borrowed from banks when starting Ambition 24 Hours-direct.co.uk. It was because of an earlier experience with her previous business when she had a bank manger who refused to call her by her name:

> but always referred to us as 'girls', was extremely dismissive of us and asked me whether I should have my husband with me when I had a meeting which really wound me up.

She says that over the first few years and still occasionally today, she'll find people looking over her shoulder when she comes into the room, waiting for a man to come in with her to the meeting:

> It's insulting when they think you're not able to start and run a multimillion-pound business as a woman. Yes, it does bug me, but I find it quite funny now and yes, it still happens.

She also believes that people can be very dismissive of a woman's success in business:

It doesn't matter how successful you are, how much you prove you can do it and how capable you are, people, including men, are still very dismissive and even amongst people I know they tend to cite a man as being very successful and yet he's probably been half as successful as I have, but they'll still go to the man as being an example of someone who's successful. I think there's a reasoning in people's minds, where if a woman has been successful it's down to very good luck, whereas if a man's been successful it's skill.

Another female trait unique to women who've started their own businesses seems to be that they find it hard to let go having established a certain level of success. Penny Streeter says:

As a woman you're always slightly more cautious. I always live with the belief that the business might not be successful tomorrow so by not working hard today it might start to go backwards but amongst fellow male directors I meet they take a different stance. They start to pull back, cut down their hours, take longer lunches, more holidays once they're established and maybe there's something within women that makes us want to keep a tab on the housekeeping.

When it comes to support, information, grants and basic advice on setting up a business or how to further your career, how easy is it to get the information you want? Streeter says she found nothing:

A lot of women's businesses are very female-oriented, they're people who've been at home with their kids and

come up with an idea like making a new form of children's beaker and there's lots of information available for those sorts of businesses but not so much on the commercial sector, like mine. I think the men have got a lot more choice at business level of the groups they can join and attend; it's very much a man's club.

It was the overwhelming lack of support for women entrepreneurs that led Maxine Benson and her colleague Karen Gill to start up their business Everywoman.co.uk five years ago. Benson says it was tough and they really struggled to find out where to get advice, and information on tax and grants available when trying to set up their own TV production company. They then realised that there were an increasing number of women who, like themselves, were starting businesses and had encountered the same kind of problems, where to go for advice, information on how to sort out your tax but were 'poor of time and money', which is how they came up with the idea for the website.

They wanted resources at their fingertips, a kind of one-stop shop but without fees, charges or costs. After starting the site, they got some sponsorship and after the initial success they built up the events side of the business and for the past three years have been delivering one-day conferences around the UK. As with any support organisation, you can't cater for everyone; Benson admits that Everywoman is really aimed at women with businesses of less then 20 employees. Anyone running a business with over that number of employees and they reckon you can afford some of the other services that are

out there. Maxine Benson says the tough part for women is also looking for new leads:

> I think when you're starting a business you've got to do a lot of mining, for prospects, for information, for everything. This is where networking can be very valuable; when you start networking with other women who've experienced the same things or had success, they're the really useful signposts and you're only going to get that by networking with other people.

This echoes Sally Preston's earlier comments about how women aren't afraid to ask other women for advice or help, whereas men often see asking for help as a weakness.

But it can be catch-22 with networking. When you're very busy working you don't keep up with your contacts or go out and meet new ones. Then when the work stops coming in, you try to get back in touch with your contacts, who, by then, have moved on, or it takes twice as long to get reacquainted and get the commissions coming in. But, as Benson says:

> You have got to get your head down, you are in operation mode most of the time but you absolutely have to make the time, you have to take out a couple of evenings a month, a week, whatever you need, to get out there and do it. It's like starting up a business and not finding the time to make the sales calls; it happens because you get bogged down in the day-to-day running of the business but if you're not on the phone dialling for dollars your business is not going to grow.

Everywoman has now launched its own awards in conjunction with Natwest but they were adamant they didn't want it to be just another awards ceremony.

Trawl the internet and there do seem to be quite a few different awards for various sectors in business and even some that recognise female achievements, but if you're in business to win some awards, you've got to know the game. 'It was my bank manager who told me about the HSBC Start-up Stars Award', says Babylicious's Sally Preston:

> But if you're going to enter for awards, you've got to put a lot of effort into filling in application forms, if you just give them a cursory glance and don't really consider all the questions and the angle, then you won't get very far but we won loads of awards last year, about six or seven.

Women start businesses for reasons other than purely financial ones, according to Everywoman's Maxine Benson:

> For many women they may have been out of the workforce for a while and don't feel employable; they've taken a break and want to try and balance some of their family commitments with work and maybe where they were previously on the career ladder wouldn't allow them to do that, so there's a number of reasons why women start businesses. What we believe is why most companies that are judged or deemed to be successful, typically the ones that make it into the papers or that get the media coverage, are those that have become large empires, very fast growth, huge

turnover and are therefore deemed successful but we don't believe that's the only way a business should be judged. So if a woman starts a business that she feels passionate about and maybe did it because she needed the flexibility, perhaps she's raising a family, so if she starts a business and it achieves what she wants then it's a successful business and she's a successful businesswoman by defini-tion. You're not necessarily going to read about her in the newspapers, so the idea of the awards was to level the playing field.

The Natwest Everywoman awards are categorised into age brackets and one age group that particularly interested me was the over-fifties; an age at which, until quite recently, women might have been anticipating retirement, entering their twilight years and becoming grandparents, not entering a new stage in their life. Now in today's society, for many women and men, if they so choose, it can be a period of new begin-nings. Women may have come out of long-term relationships, be starting again, finding that with the children leaving home, they've got the opportunity and money to start their own business or feel the need to do something for themselves at long last, maybe even indulge a personal passion.

One of the finalists in this year's over-fifty category is Carole Nash who runs an insurance company for vintage motorcycles. In her late forties, Carole Nash was made redundant but used the redundancy cheque to set up the business. Known as Nanny Nash, she combines her family life with grandchildren with the business. Another woman in the over-fifties category

was a woman married to a man who ran a hotel; having brought up four children, when her husband died suddenly, she decided to take on the business having, according to Maxine Benson 'had no direct business experience and has since gone on to become incredibly successful and gives talks around the world'.

If I had to sum up this chapter, I'd say how important it is to recognise that we all need support and endorse Sally Preston's view when she says that she's been able to get a lot of help purely because she's asked for it. Support can come from many directions, maybe for some it can be through religion and for others through family and friends. I have to be honest and say I hold with Penny Streeter's view that if you seek the advice of too many people, you could procrastinate forever or risk being pulled down. I believe you've got to hold onto your dreams, be true to yourself and don't give up if someone comes up with a negative view. For every person out there with a negative view, there may be someone with a positive and encouraging one.

I can still remember being quizzed by my next-door neighbours once on the subject of what I wanted to do when I left school. As a ten-year-old I remember saying that I wanted to be a DJ (even in those days I had serious aspirations to work in the media), whereupon she laughed and said 'what funny ideas children have these days'. The ultimate put-down, even for a ten-year-old but, ironically, after a lot of hard work, persistence, hopefully some talent and the help of a few people down the line, I did end up presenting radio programmes.

I'd have to say from my own perspective that over the years a huge amount of my personal support has come from my family, in particular my parents. They didn't laugh when I came up with various ideas of jobs I wanted to do within the media. In fact I think they've probably listened to every radio broadcast I've ever done; even back to the days of make believe when I sat recording pretend programmes on my tape recorder! They've watched every TV appearance and probably bought the equivalent of a small rain forest over the years in magazines and papers when my articles have been published. When my school careers teacher offered me the chance to work at the local gas board for my work experience week after I'd told her how much I wanted to work in the media, it was my dad who rang our local theatre and sorted me out with a week's work experience.

As Sally Preston from Babylicious said, you can never under-estimate the power of family and friends when it comes to support and in any aspect of life it's crucial to have some support when the chips are down, whether it's your female friends, your business partner, your partner, husband or parents. Although we may be doing it for ourselves, we can't do it all single-handedly.

chapter 8

WOMEN IN
THE MEDIA

The power of the world's media is a force that affects all our lives. Every minute of every day 365 days a year the world's media is broadcasting on radio and television in some shape or form. Naturally what the world's media broadcast and print isn't always well received. Just think of the number of injunctions, libel cases and people claiming an invasion of privacy that hit the headlines. In this chapter, we'll look at the way women shape the media, their influence and those who are responsible for shaping both our perception of world events and entertaining and educating us. We'll also look at women's portrayal within the media and in areas like the news, which was once pretty much a no-go zone for women.

Open your paper, turn on your radio or switch on your television and, within a relatively short time, chances are you'll find a pretty equal mix of male and female journalists, presenters, broadcasters, actors and actresses. On television and in the movie industry there are men and women working on both sides of the camera; take, for example, the Oscar-winning

Hollywood actress Jodie Foster who, after many notable films, turned her hand to directing and producing; others, like Liz Hurley and Hugh Grant act as well as running their own production companies. Once women may have been there merely to provide the 'fluff' factor – something glamorous, light and frothy to watch – just think of the long list of 'Bond' girls whose greatest talent seemed to be nothing more than the ability to look permanently stunning in the smallest bikini available. On TV, women have often been used in the glamorous hostess role, to liven up game shows or add light relief between the more serious newsworthy programmes but nowadays it's a very different set-up.

Firstly let's look at the number of women who are quite literally running the show! Within the BBC the two controllers of BBC 1 and BBC 2 are women and the BBC daytime controller and the director of television are also female. On the other side of the Atlantic it's a mixed picture – research by the Annenberg Public Policy Center at the University of Pennsylvania in 2002 claimed that less than one in five board members of the largest communication companies were women. Just three years ago, two of the big US networks Fox Entertainment and USA Networks had not a single woman among their top executives. Yet there have been trailblazing women in the American media, for example Geraldine Laybourne the chairman and CEO of Oxygen Media and the force behind the creation of Nickelodeon, who have paved the way for others. Anne Sweeney, president of the ABC Cable Networks Group and Disney Channel Worldwide is also a widely respected name in the industry

and the American cable station Lifetime Entertainment Services is run by President and CEO Carole Black and reaches an estimated eighty-five million households covering predominantly women's issues.

Women on television and the big screen can now command huge salaries, a clear indication of their pulling power. World famous names like Catherine Zeta-Jones, Nicole Kidman, Jennifer Aniston, Goldie Hawn, Sarah Jessica Parker, Demi Moore, Julia Roberts and Madonna are recognised for their talent as well as their on-screen pulling power. The actress Halle Berry made headlines twice over when she scooped the Best Actress Oscar, the first black actress to win in the 74 years of Oscar history.

Looking at television news programmes, I'd be hard pressed to find one where the two anchors were of the same sex – the boy-girl line up is one that's highly favoured. But historically news was always considered a man's territory, although these days women don't just get to sit in the comfort of the studio. They've been sent around the world in the name of journalism and caught up in some terrifying situations. Yvonne Ridley, a *Sunday Express* reporter, was captured by the Taliban in 2001 and Kate Adie became synonymous as the BBC's chief news correspondent, with reports from war zones around the world including the conflicts in the former Yugoslavia, Albania, Rwanda, and China, possibly most memorably the brutal suppression of the student uprising in Tiananmen Square, Beijing. More recently, Orla Guerrin has been the BBC's Jerusalem correspondent, highlighting at first hand the Middle

East conflict. Female reporters on our screen also include Sky News's Lisa Holland and the diplomatic editor of ITN Channel 4 news Lindsey Hilsum who was in Baghdad during the war against Iraq. Going back in time Mollie McGee was the first Canadian woman war correspondent covering the Second World War. More recently, CBC's Ann Medina was one of only a few women in Lebanon in the early 1980s and Christiane Amanpour is American news network CNN's top war correspondent.

History was recently made in Saudi Arabia when Buthaina al-Nasr became its first female news presenter when the country launched its all news TV satellite channel Al-Ikbariya, broadcasting in Arabic (BBC News, 2004).

In the US Barbara Walters made history when she joined ABC in 1976 and became the first woman to co-host the network news. According to biographical material about her, it's believed she may well have interviewed more statesmen and stars than any other journalist in history, having interviewed every American president and first lady since Richard Nixon. She co-hosted the ABC news magazine programme *20/20* before becoming the sole anchor, but interestingly began her career as a writer and then a reporter. When it comes to successful women on American TV and in fact pretty much worldwide TV, you can't get much higher than Oprah Winfrey, who herself was once a TV newsreader and is now America's most well-known chat show host – and according to reports she is well on her way to becoming the country's first black billionaire businesswoman.

But while from the outside it looks like we have equality on screen, in the media is this really the case? When it comes to the subliminal messages being sent out, are we still being encouraged to believe that the man is taking on the lead role while the woman is merely there in a supporting role? Dr Cynthia McVey, a psychologist at Glasgow Caledonian University, believes this is the case. Dr McVey also has experience of reality TV shows as the resident psychologist for the BBC series *Castaway* which followed the lives of 36 people who volunteered to live on the remote island of Taransay for a year. During our conversation she raised the subject of the subliminal messages we're sending out in the media. She said that as we read from left to right, so in watching a news programme, we read the screen in the same way. In general, news programmes lead from left to right so that you focus first on the man, on the left in the leading role, before looking at the woman who will often be on the right. In looking for proof in Dr McVey's theory, I've tried to make mental notes when watching news programmes or chat show programmes to see which positions the male and female presenters adopt. I've found some that adhere to her theory while others seem to adopt the style of switching seats on a daily basis. In some instances, the traditional style of news reading from behind the desk has been superseded by the latest trend for presenters to stand, walk and move around the studio as much as possible.

Following on from this theory, McVey says it should revert to the woman on the left and man on the right in countries where they read from right to left. Maybe the message isn't as

blatant as that, but Denise Knowles, a counsellor for Relate, the relationship guidance organisation, and herself a regular interviewee on radio and television, says there's certainly a degree of playing to the presenter's natural gender strengths. Denise says that if the interview is centred on an emotional subject, it's likely the female anchor will do the interview and if there's an interview with a government minister or hard news subject, it's generally male territory:

> When it comes to seriousness, a man in the media is still perceived as having a serious slant and women are perceived as being better at covering emotional issues.

Having herself been interviewed by both men and women, I was interested to know what differences in interviewing style Denise had noticed between the sexes. She says:

> When a woman's doing the interview she's often happy to take an emotional slant, whereas a man is more likely to favour the factual statistics and figures behind the situation.

One universal trait between the sexes when discussing relationship issues is that:

> If things get a bit sticky, both men and women revert to slagging off the genders. They do the 'that's men for you' or 'typical women' style of comments until they feel they're back on familiar territory.

But while there may be a number of women who've success-fully made it onto our screens, Dr McVey says that while the male/female set-up on chat shows and news programmes may be popular with the viewers, it can still be used to subtly reinforce the message of control and who's in charge:

> Women need to be younger and up to now have been relat-ively young and relatively cute. They can be paired with a man who is older and more experienced and he can, just by the very difference in their ages, and the difference in their experience, make her look not as competent as him. If you look at two presenters who are male and female, in ninety-nine cases of out a hundred you'll find that the man is considerably older than the woman, which means he's got more experience at his fingertips so if anyone's going to compare their intellectual ability it's likely that she'll come off worst but that's because she's got to be young and cute to get on the screen anyway.

The whole issue of how attractive women need to be for tele-vision has come under criticism. McVey's view is that:

> There's generally an awareness with women that female television presenters are young and cute and gorgeous and that puts extra pressure on them.

That's not the first time that kind of view has been aired – reporter and journalist Kate Adie was once said to have caused uproar in the BBC when she accused it of hiring female presenters more for their looks than their talent, saying

that the BBC wanted 'women with cute faces, cute bottoms and nothing else in between'.

Interestingly, when female newsreaders get letters from the public, it's not necessarily a commendation for the report or the way they handled an emotive news subject but a comment about the colour of their jacket or why they've had a new hairstyle. Cynthia McVey says that's a reflection on our society and can be traced back to the early stereotypes of women having to look visually appealing to attract men, whereas men would attract women by the power and protection traits:

> You watch the male newsreader, if he looks authoritative, if he's assertive and comes across as intelligent and in control, he will be admired but when it comes to the woman, they were not supposed to be assertive traditionally and the important thing was how she looked and we're just now at the beginning of changing this attitude.

Think of the traditional style of news reading and it was very much from behind the desk; these days newsreaders are frequently seen perched on desks in the television newsrooms or walking across the studio trying to give the programme a more relaxed look. It dispensed with the more serious image synonymous with male newsreaders and it's a format that has since been reproduced on numerous news programmes and networks.

One of the biggest differences between the media and some other industries is that it's certainly not frowned upon to have

started out as a secretary and worked your way to the top. Lorraine Heggessey, the first woman controller of BBC 1, took over her role in November 2000 having started her career in the BBC in 1979 as a news trainee and Alison Sharman, BBC daytime controller, began her career as a production secretary on the consumer programme *Watchdog*. Sophie Raworth, an anchor presenter on the main BBC teatime news, also started on a trainee scheme back in 1992 at the BBC and Kate Adie began her career working in local radio in Durham. There's seemingly no prejudice about promoting from within the industry or in having worked your way up from the inside. In the boardroom chapter, we looked at whether it's possible for the office secretary to make it in the corporate world to the dizzy heights of the chief executive's office and while there's not yet been a female director general of the BBC, who knows what could happen judging by the number of talented women running the programming side.

Although she started her career as a production secretary on *Watchdog*, Alison Sharman has also worked outside the BBC – at BskyB, TV-am and Channel 4 – but says she knows women who've been secretaries and worked their way up the ranks of the BBC without ever going outside the corporation:

> As an organisation I think the BBC has recognised the importance of promoting people on merit and having a wide cross-section of people, men, women, diversity and that's what it's about.

Talking about her current role as controller of daytime television, she says simply: 'Had I not been up to the job I wouldn't have got it.' She is a firm believer that that's the way it should be – promotion on merit.

But as with all successful people, whether men or women, a key universal trait is being able to focus on your goals and know what you want – in Alison's case it was to work in programming. She joined the BBC in human resources for six weeks:

> I'd come to the BBC to work on television programmes; that was what I wanted to do and I didn't ever think I wouldn't be working on television programmes but there I was as a secretary in HR.

One potentially daunting project was to get a huge document typed within 24 hours; she tells the story of how she was offered a salary bonus if she completed the job on time but refused the money, and asked instead whether she could work on a TV programme if she completed the project.

> I was very clear at that stage about what I wanted – the money would have been very nice – but I typed it up and I did get to work on the programme two weeks later which was *Watchdog* and the experience I gained from working on the programme as a production secretary was fantastic.

Ironically enough in her next job, after leaving the BBC to 'spread her wings', she worked for an advertising agency where she says it was 'much harder to get out of your role as a secretary. It was a case of you were secretarial and were going to do a secretarial job.' Having previously believed the BBC would be less proactive when it came to pushing people forward, she rapidly realised it was in fact the reverse and in her experience it was the advertising agency where she felt very 'locked in' by her role.

Ultimately the media is quite a step ahead from many other organisations, with the responsibilities women have both on screen and off screen. I work in a very female-dominated area; the controller of BBC 1 is female, the controller of BBC 2 is female, the director of television is female. I haven't worked for a male boss in ten years. What television has realised is there are huge benefits to not having a big white male middle-class perspective; there are huge benefits in having that breadth of opinion, of attitude, of faces and I guess that society has changed absolutely fundamentally in the amount of women who are going out and working, who are single mothers, and the importance of women in society that we all recognise and television is at the forefront of that. I forget how fortunate I am – I can walk into any meeting in the BBC and be regarded equally by both my female and male colleagues – their attitude towards me is hugely different to what I imagine it would have been twenty years ago.

As we've already seen, starting your media career as a secretary or trainee can often be a great way to get a foot in the door and it can often be an opportunity to venture across to the other side of the camera too. In other industries, secretaries might never get beyond the typing pool but within some aspects of the media starting out as a secretary is far from being something to be looked down on. Getting a foot on the first rung of the ladder in some shape or form can be a sure-fire way of opening up more opportunities when it comes to getting to the top.

But for anyone who has experienced the world's media at their feet, it's worth remembering the power of the media, particularly the press, when it comes to knocking you down. Journalism can be a fickle world and while some people in the limelight seem to court the press, it can backfire if you're not careful. Probably the prime example of this was Diana, Princess of Wales. From gauche beginnings, she appeared to develop the knack of turning any event into a front page spectacular and was accused of deliberately manipulating the media to her own benefit; in some cases, it was argued, to outdo Prince Charles and knock him off the front pages. Who could forget the famous Panorama interview in 1995 with Martin Bashir? Since her death there seems to have been no shortage of people ready to crawl out of the woodwork to unburden their story to the world, complete with supposedly salacious gossip, in return for a large, lucrative fee.

Another aspect of working life that I've raised numerous times throughout this book is the perennial problem of not only how to combine work with family life but how to cope with the outdated but underlying attitude from many employers that once you've had children you're on the scrap heap as far as returning to a successful career is concerned. Alison Sharman, the BBC's daytime controller, is herself married with two children aged seven and nine. She says even when she was having her children it was always assumed that she'd return to work. Maybe a lot of that could be down to the attitude of those around her – she was working at the time for a woman!

> I was working for someone who assumed that after having my children I'd be coming back to work and because that person had done the same thing I was very encouraged; it wasn't a case of not wanting a working mother to come back but very much 'don't you dare not come back'.

However, when she left to have her first baby, she does recall one male colleague saying, 'oh great for you having a rest' and a similar comment when she left to have her second child, and says that although she found it amusing rather than offensive she was also shocked because she'd never experienced that kind of attitude before. Sadly, comments like that are probably more commonplace in other industries – there have been cases in the press of women claiming to have been sacked because they became pregnant.

In my own experience in the media I don't recall ever feeling 'held back' because I was a woman. Even when I was six months pregnant I was still working freelance as a business reporter for the BBC and, no, I wasn't given the 'easy jobs'. I can recall one day spent charging around London for three different interviews for my evening report and most of it spent jammed in some of the capital's sweatiest and busiest tube trains! In fact the one time in my life when I distinctly recall any form of sexist slant was when I applied for a job at my local bank when I was 18. The assistant manager interviewed me about my qualifications and ambitions and then proceeded to ask whether I saw the bank as a means of temporary work between leaving school and having children!!!! As I don't work in the banking industry, I have no idea whether that would still be their style of interviewing.

Let's move away from the TV screen for a moment and look at women in print journalism. Rebekah Wade made the headlines on becoming the first woman editor of Britain's biggest selling daily paper, the *Sun,* when she took over from David Yelland. Infamous for its page three poses, the question of whether Wade would dispose of these or not seemed to capture public interest; but the famous page three girls are still going strong.

America has been a notoriously hard egg to crack for many British artists, performers and entertainers but Anne Robinson is one former Fleet Street journalist turned TV presenter who has made it on both sides of the Atlantic with amazing success with the quiz show *The Weakest Link.*

Robinson is famous on screen for her caustic humour and attempt to publicly humiliate contestants, but still they go back for more. Once voted the rudest woman on television, she's certainly broken the mould of sugary sweet and sickly TV presenters and, ironically, audiences love it. She's been quoted as saying: 'People have called me lots of names, but they've never called me stupid.' Maybe this is the deciding factor in how we accept and view women in the media; are they just of the clotheshorse variety, with nothing more than a desire to be famous and a smattering of TV experience, or do they actually have something about them, a talent or natural ability with people? However, Robinson's vote for rudest woman on TV is hardly one that most female TV presenters would choose to win.

One aspect of the media I find fascinating, amazing and at times, dare I say, a bit sad is the whole concept of reality TV shows. In general they're big audience pullers; you'd think we'd get bored watching a crowd of people go about their day-to-day existence in the goldfish bowl of the *Big Brother* house but *Big Brother* is a phenomenon that's caught on the world over. It follows a similar theme where people desperate to get on TV and have their 15 minutes of fame are locked in a house together until a couple of months later they're down to one by process of group nominations followed by eviction. OK, you may find the odd couple of people with some true natural talent here but the vast majority, in my opinion, are just people who want to be 'somebody' and who dominate the nation's newspapers and breakfast table discussion for a few weeks before fading back into obscurity. Programmes where

you have to spend weeks in the jungle or marooned on a desert island are popular too, with the celebrities themselves looking to promote their latest book or give their career a bit of a boost in another direction. Clearly here are experts in the power of the media and how to use it to your advantage, but even the celebs don't always come off as well as they'd hope. In some cases it can be the launch pad to a different career path but get it wrong and it's a sure-fire way to obscurity and being a national laughing stock.

But what sets the real talent apart from the very attractive fluffy types who are ten a penny? 'With *Castaway* it was different', says Dr Cynthia McVey, resident psychologist on the series.

> They applied for the experience, not just to be on television. They had a lot to give up, they were rejecting the trappings of civilisation, so to speak – with shows like *Big Brother* they all want fame. With women, self-esteem is more of an issue and they're looking for people to accept them and find them attractive, whereas the men see it as an opportunity for making themselves more employable – there's a small but subtle difference.

But once you've achieved notoriety and/or fame within the media and entertainment industry, you can use it as a platform for highlighting emotive issues. There are plenty of examples, from Pamela Anderson, the former *Baywatch* babe talking about contracting hepatitis C in an interview with *Marie Claire* magazine, to Esther Rantzen launching Childline and daytime debate show host Trisha Goddard revealing in inter-

views how she's battled with depression. Instead of colluding with the illusion that the rich and famous have charmed lives, they've gone against the grain in speaking out about personal and emotive subjects. I think it's a huge testament to their inner strength that they feel able to talk about these issues on a public platform without worrying that it could harm their career or have an adverse effect. Maybe they do worry that it could affect the way people perceive them but if they do they are still are strong enough to share the insights into their personal and private lives with the mass public. But while many 'celebrity' interviews might be given to promote a book, film or forthcoming TV series, I find the most fascinating are those where they do reveal a little of themselves, the real person behind the screen personality rather than just a two-dimensional presenter.

chapter 9

WHO WEARS THE TROUSERS? WOMEN IN RELATIONSHIPS

'Girl power' has never looked stronger. While the world's boardrooms may still be run largely by men, when it comes to relationships and family life it's women who frequently wear the trousers. Women have learnt how to be individuals within their relationships and also emerge as the leaders in family life. Just take a look at the number of women heading up single-parent families as the sole breadwinner. We're not only leaders in practical terms in these situations but we're also emerging as leaders when it comes to our emotional strength and inherent sense of survival, which comes to the fore when we're under pressure whether through work, family or relationship problems.

As women we've made such a huge and amazing leap in our personal lives. When Neil Armstrong first walked on the moon in July 1969 and uttered the immortal words, 'That's

one small step for man, but one giant leap for mankind', it was a phrase that went down in history but it's a phrase that could also be applied in another gender to the way that women have managed to carve out their own unique niche role in society. Sometimes quietly, by being the silent matriarch of the family who held it together in times of strife or trouble, and sometimes not so quietly, think of women like Emmeline Pankhurst in the early twentieth century campaigning to get women the vote, but step by step, we're constantly widening and opening out new horizons and greater opportunities for our friends, colleagues, children and grandchildren.

Going back, say, even 50 years, take the stereotypical image of the traditional stay-at-home wife who even if she wanted a career on the same scale as her man would have had to fight twice as hard as today's woman to achieve it. So whether she was brought up to believe that a woman's place was in the home or had sacrificed her own needs and desires because of society pressure, she was generally the one who took over the leading role on a daily basis within the family bringing up the children and caring for her husband. This may well be the case in some cultures around the world even today, for example within the Muslim community. Other countries like Italy and Australia have cultures whereby the extended family plays a huge part in family life and can well ease the burden of childcare. According to research from Monash University's Centre For Women's Studies in Australia, the effect of shared parenting can have an altogether different effect on family life. Indigenous Australians, according to the research, have a

community approach to raising their children and parenting responsibilities are shared by extended family, neighbours and friends. In Aboriginal communities, an increase in family breakdowns has meant grandparents taking on a much larger role in bringing up children, whereas, by contrast, in typical Anglo-Saxon families the increase in family breakdowns means that grandparents are increasingly cut off from the parenting role and even having any contact with grandchildren.

In this chapter we'll look at the effect of women's decisions on their lives. We'll look at why, according to research, women are predominantly responsible for filing for divorce and in some cases actively choosing life as a single parent rather than remaining childless if they don't meet the 'right' man. We'll also look at why women are taking even more control of their lives by making a conscious decision to delay childbirth until later in life or in some cases choosing to remain childless.

The creation of Helen Fielding's lonely spinster character Bridget Jones constantly seeking a man has been replaced by a new breed of financially independent, single, confident women. Even within a relationship many women now earn their own money and don't rely on a man to support them financially. In fact it's not uncommon in relationships these days to find the woman's earnings outstripping those of her partner, or even the woman taking on the role of breadwinner while the husband or partner takes on the role of caring for the family. We're entering the property market by ourselves and not taking the traditional route of living with parents until

our wedding day when you might finally have flown the nest to rent or buy with your partner. And should the relationship break down we're not running back to the safety of our parents; as we'll find out many women flat share or buy independently following a break-up.

In a BBC Radio 4 discussion programme *Home Alone* broadcast in August 2003, Kenan Malik opened the programme with some hard-hitting facts about singledom. Seven million adults live alone – that's three times as many as 40 years ago – and those numbers are expected to double over the next 20 years, so whether you're a man or woman, the facts remain that more of us are single or becoming single, a status that, as we'll find out later in the chapter, women are better able to handle, both physically and mentally, than men.

When women do find a partner, it now seems that, like male behaviour throughout history, we're not always satisfied with just the one person. From the days when it seemed men were the ones to have mistresses, an 'indiscretion' openly tolerated even in royal circles, just think of examples like Charles II and Nell Gwynne, the tables have turned and women are now actively choosing to have affairs. I say 'choosing' because there are numerous cases of women who are unhappy with their lot at home, claiming that they're viewed purely as a wife or mother and not as a sexy, attractive, confident woman but don't want to break up the relationship for the sake of the children. So, it could be argued, they actively 'choose' to have an affair for that extra buzz and excitement rather than looking for a different life partner.

Relationships where a woman lives with two men aren't unheard of either. I read a fascinating article in a 2003 issue of *Marie Claire* magazine about a woman in Silicon Valley, USA who lived with two men. Despite the initial teething problems, all three got on famously and the men claimed to get on like brothers. That's not a setup that would appeal to me, but it's an example of a woman in today's society 'having her cake and eating it', an expression that's often been used in connection with men over the years. Look at the numerous sects where men are allowed to have more than one wife, so why not women? Even a flick through some of the weekly and monthly women's magazines will produce a story about a woman claiming to live with her current partner plus an ex-husband, old boyfriend or someone they've previously been in a relationship with.

Single women living alone have become a major force in the property market, according to research from mortgage brokers Charcol. There's been a 50 per cent increase in the number of single women buying their own home in the UK since 1992. We're snapping up one in seven properties and account for at least 17 per cent of all new mortgage lending. With the average UK home loan now topping £100,000, these aren't women in low-paid jobs but financially independent women. What I find interesting in this is women's rejection of the 'once bitten twice shy' syndrome; 36 per cent of female homeowners are women who've re-entered the mortgage market after having previously owned property jointly. As I mentioned earlier, running home to mum and dad just isn't an option for the vast majority of women these days. Of course

in some cases these women may have co-owned with a brother or sister before buying for a second time but, with rising divorce rates and relationship break-ups, chances are these women have previously owned with a partner but are now doing it alone because they can and because they want to. It's more expensive to live alone but, instead of sharing, many women make a conscious choice to live alone.

While we're on the subject of money – and this is one subject that can cause the most amicable of break-ups to get acrimonious – I fear there are some women out there who file for divorce yet revert to the 'kept' woman syndrome when trying to cream off the financial 'rewards' in a divorce settlement. Of course there's a strong argument that, although some women may have taken time out from the workplace to bring up the family, they've not been contributing financially but have been doing a valuable job in bringing up children, so shouldn't be expected to start from scratch five, ten or twenty years down the line. But equally there seem to be a large number of women who think it's OK to get a divorce but still expect to live off their ex-husband. Now I'm not going to pretend to be a divorce lawyer and know the nitty gritty of how the system works, but how can any self-respecting woman expect not to go out to work but be supported financially by a previous partner? What example does this give to our children? Of course there are some more complex issues at stake and clearly some jobs aren't very well paid, which means by the time you've covered the cost of childcare you can be coming back with next to nothing but that's not the case with all jobs.

It's an issue that I think threatens to take women back to the dark ages unless we're careful. While we might like to think we can have it all when it comes to family, career and children, you can, just, by the skin of your teeth, but when it comes to ditching the husband, keeping the house and the cash – you just can't do that and keep your self-respect!

Let's take a deeper look at women in relationships. I believe that women can at times be the stronger sex, not because that seems a great sexist thing to say or because I'm some kind of feminist, but when a relationship breaks down after however long, in my experience it's the woman who always seems to come back stronger and more successful than her first reincarnation. Whether this is a form of revenge, with the 'I'll show you' syndrome, or the realisation that a partner has held them back and they can now truly be their own person, many women find it's really the turning point in their lives. You've only got to look at high-profile celebrity couples like Tom Cruise and Nicole Kidman to see that when the relationship hit the rocks, it seemed, allowing for any media slant, that it was Nicole who got the plum roles, and was doing well in the award stakes, winning a Golden Globe award for her performance in *Moulin Rouge* within a year of splitting from Cruise. She was generally seen as getting her life back on track in a strong and dignified way without resorting to getting her name in all the gossip columns as some lesser celebrities might have done. To give him his due, neither did Tom Cruise from what we saw but it seemed for a while he fell from favour until the more recent advent of the 'Cruise walkabout', where he meets the masses, leaves messages on fans' mobile phones and

generally stays outside in occasional sub-zero temperatures doing a meet and greet before attending a premiere or function.

So who better to get another perspective on the whole relationship issue than Denise Knowles, a relationship counsellor for 14 years with Relate, the relationship guidance organisation, and someone who is frequently interviewed on radio, television and in magazines and newspapers. Denise is married with three children. She says that over 70 per cent of divorce petitions are now lodged by women. Now before we assume that those figures automatically mean there are a lot of unhappy women out there, it doesn't necessarily mean that it's always the woman instigating the divorce, on the grounds that she's decided she's outgrown the marriage, wants to pursue a career or carve out a different role for herself in life. These women could be instigating divorce as a result of a husband's affair, so in some cases it may be down to nothing more than women being the ones who finally get around to completing the paperwork.

But from her counsellor's perspective, Denise Knowles says she sees an increasing number of women who are dissatisfied within their marriage or long-term relationship:

> There's not anyone else involved but it's just a case of thinking, there has to be something more or I'm not being fulfilled sufficiently here.

She says it's these key areas of thought that are leading more women to think about moving on from their relationship. And it's not just women contemplating a fresh start; more women are getting divorced later in life, after maybe 20–30 years of marriage:

> A woman might want to return to work for her career or even start a new career of her own and in some cases that coincides with a time when the man might be in the process of being made redundant or feel he's on the scrap heap. He might have peaked in own profession and feel that his partner might be on the way up while he's on the way down. Retirement is always a tricky one; women with partners in their fifties sometimes claim their partner is old and settled and comfortable and a lot of men aren't realising that, although they're in their fifties or sixties, they don't have to get the pipe and slippers out. Women are having children later and by the time they get to their fifties, they're thinking, 'I've got a lot of life behind me but still a lot of life ahead of me.' Traditionally, being in your fifties meant you could be settled with the grandchildren, were a bit menopausal and 'you'd done your feminine bits', you were meant to be mumsy and simply 'OAP' material and that view that women had of themselves has now gone completely out of the window.

She says she sees more and more women going clubbing, having girlie nights out and holidaying on their own because their partner can't be bothered and would rather stay in and watch television than go out:

Now women can go out and do these things without there being too much criticism; a few years ago there'd be the feeling that 'why are you throwing away all those years of marriage? What are you going to do?' Whereas nowadays a lot of women are looking at their peers wishing they had the same kind of courage.

Whereas once we might have stayed married for 20–30 years until death, as we're now living longer you could face around 50–60 years with your partner. So are we starting to view relationships as another part of today's disposable consumer society? Women are becoming so confident in themselves that they now realise there's no need for them to stay in an unhappy relationship or one where they don't feel fulfilled. There's also plenty more opportunity for women to meet other potential life partners, either through work or social circles, which takes away that fear element many of them might previously have felt about being 'left on the shelf'. Now I'm not suggesting that you should jack in a relationship on a whim. Even if you do decide to leave, in many cases, whether due to financial constraints or a potentially violent relation-ship, it can be very hard but, in general, woman do have the power and are choosing to leave relationships, whereas men often seem to trundle along until they meet someone else and can then leave the relationship. The divorce rate in the West is high; according to one online divorce magazine, the US, the UK and Canada all have around 50 per cent of marriages ending in divorce, whereas in countries like Albania and Uzbekistan you're looking at 7–12 per cent.

A relationship break-up is the crunch point where I believe women's true emotional strength kicks in. 'Men on their own do not fare as well, physically or emotionally, as women do', says Knowles. Where it might be socially acceptable to go round and cry on your closest girlfriend's shoulder, for many men, talking about relationship issues and even admitting to a break-up is difficult. One male friend of mine didn't even realise that a close male colleague of his had split up from his wife until the man suddenly blurted it out some six weeks later one drunken night in the pub.

Is this actually very sad that he felt he couldn't even tell his closest friends or could this be an example of men's inner strength? Women would rather talk about a situation, analyse it and discuss it, while men would rather nail down the lid on a difficult situation.

As I mentioned earlier, you've only got to look at some of the celebrity couples to see that break-ups can often signal the beginning of a whole new and positive chapter in your life. Sometimes staying single can even be better for women's health! Read on! Researchers at the University of London found in studies that women who stayed single enjoyed much better mental health than those who had married or suffered a relationship split. But the same was not true for men, who fared much better emotionally when they were in a relationship. Could this be one reason that so many men seemingly bide their time before ending a relationship when they meet someone else rather than being upfront and honest about the state of the relationship, sometimes many years previously?

The research also found that serial relationships were benefi-
cial to men's health but could have an adverse effect on
women. While men did better mentally if they simply lived
with a partner, marriage was more beneficial to a woman's
mental wellbeing.

So how does this attitude compare with women in the US?
Margaret Draper is the co-chair of the marketing communic-
ations committee at the Financial Women's Association based
in New York. The group was founded in 1956 when a group
of eight women on Wall Street were prevented from joining
the men's investment club. They formed their own group,
with the emphasis on shaping women leaders in business and
finance, and now have branches in Boston, Chicago and
Washington DC. Margaret Draper says that in America
'women are very much empowered to make their own
choices'. Draper herself is very much part of a trend of single
women who:

> aren't waiting to reach a certain age to establish a nice
> home, settling down with a man, but are going out and
> buying a home themselves and getting to the point where
> they can buy and maintain a house on their own income;
> you don't need a dual income to afford a residence.

She says that the whole issue of whether taking time out to
raise a family is detrimental to your career is just not an issue
that's really discussed:

Women do drop out of the workplace to raise a family but more and more firms are making allowances, in terms of long maternity leave and not questioning the fact that you've had time out, it's not seen as a black mark on your record.

But when it comes to getting back in where you left off, it's not something that usually happens by chance:

You have to plan for it; a woman must take the responsibility for keeping up her career skills and her career network. More women are making the effort to do this; they're not getting out of the work cycle completely.

One high-profile example of this is the case of the former boss at Coca-Cola UK Penny Hughes, who gave up her six-figure salary to bring up her family but kept her hand in outside the office with a number of non-executive directorships.

Draper herself cites the example of Sally Krawcheck, one of the most respected business leaders on Wall Street and the chief executive of Smith Barney the investment banking company. She's been named by *Fortune* magazine as the country's fourteenth most powerful woman and is a lady who combines her career with a husband and young family. Thirty years ago no woman was the head of any publicly traded company that she did not inherit. Today in the US, Krawcheck is by no means unique – women own 49 per cent of American businesses operating in the US, generating $1.15 trillion in annual sales, according to the Census Bureau. Of the sixty-five million working women in the US, over half are

professionals with disposable income. After only three decades of being mainstream members of the workforce, one in three wives now makes more than her husband, according to Women and Company (financial advice for women) President and Chief Executive Lisa Caputo who has worked closely with Krawcheck.

There are other high-profile examples, such as Carly Fiorina, the chairman and chief executive of Hewlett Packard, the global computing company. Not someone who's a chief executive in name only, she spent 20 years with AT&T and has an assortment of degrees and qualifications from American universities to boot. Interestingly, her appointment was the first time in the company's history it looked outside to fill any of its top jobs. And in a corporate culture where you've got to inspire loyalty in your workforce, Carly Fiorina is known for her generosity in giving flowers and balloons to employees who land big contracts, according to an interview in the American *Business Week*.

But in becoming increasingly successful, is there a price to pay in terms of our relationships? Can our men handle our independent success within the parameters of the relation-ship? Men react to confident, successful, independent women in different ways. I think it takes someone who's confident in their own ability and comfortable in their own skin to cope with a woman who's successful, is a person in their own right and maybe manages their own career. Traditionally it was the man who went out to work and returned home every evening to talk through his day with his wife or partner, who may have

felt they had less to contribute, having been at home with the children. But in this day and age, it's more likely to be both partners coming home late in the evening. If, for example, the female partner is in public relations or a sales environment, she could be out entertaining clients until late at night or working late to meet project deadlines. Suddenly the tables have turned and both sides have partners needing to offload and unburden themselves and get support from each other. The old game of whose career is more important is probably played out in many relationships but in my view it takes a very confident male partner to cope with a woman's success without feeling threatened, challenged or intimidated.

And let's face it, the threat of a partner's job doesn't just end with the nine to five routine. Depending on their role, it could involve having to attend launches, parties, dinners, having the boss round for dinner, and whereas this might once have meant the woman cooking an elaborate meal to curry favour with her husband's boss, it's now more likely to be the other way round, with the woman taking her partner along to office functions or inviting work colleagues round. So you need to be confident that your own partner will be comfortable and able to hold his or her own in that environment. I will always remember a couple I met where the man told his partner he didn't want her coming along to his work social functions because she basically wasn't glamorous enough and 'she was an embarrassment'! So you need to be assured that your partner is able to handle these situations and is strong enough not be phased if colleagues are talking about your success instead of about his own.

On a personal note, one of the things I particularly value about my partner is the fact that he wasn't and isn't the least bit phased by the job I do; when I came home from presenting a radio programme and told him I'd interviewed a couple of rugby players, he laughed and asked why I hadn't invited the whole team into the studio. He's not going to huff and puff if I work late and when I've been invited to awards evenings and posh parties, of course he wouldn't mind the chance to come along but it's not a problem because he's equally successful in his own life and career.

Think of the number of celebrity couples you've read about where when one becomes more successful than the other or the lesser-known half of the duo suddenly manages to revive a flagging career, then the relationship hits the rocks. And it's often the same when you come from nowhere; someone hitting the 'big time' and becoming known in the media, a route that gives you an instant passport to a trail of celebrity parties, exclusive bars and venues, can often result in the partner from years ago being dumped quietly behind the scenes as their new celebrity lifestyle takes off.

Going back to the point about women having to attend functions, entertain clients and go to work-related events brings me to another interesting point – escort agencies. It's now not a social taboo for a woman to approach an escort agency needing a date for the evening; in fact if, for whatever reason, you feel uncomfortable going out on your own or know that other people will be partnered and you don't want to be the single woman, then fair play to them. Of course, as

any self-respecting girl would know, you're going to check out the agency and do your own research and do all the usual things you would do when meeting a date for the first time, like not giving out your home address and too many personal details but it's a perfectly acceptable option.

Although the number of women in paid work has greatly increased during the twentieth century, this hasn't been matched by an increase in men's participation in household and caring work, according to the One Plus One Charity that looks at marriage and partnership research. Try telling us women something we don't know; juggling a full-time job, kids and a home is second nature to most women, they're probably planning the shopping list in their sleep.

But along with choices about their career, they're also making conscious decisions about the family and many women are choosing to delay childbirth until later in life. According to the Office for National Statistics, 11 per cent of women born in 1925 were childless at age 35; this number rose to 25 per cent for women born in 1965 who reached age 35 in 2000. Around one in five women has not had a baby by the time she's 40 and women are choosing to have less children; the average is now less than two children per household. In some cases women are choosing to remain celibate or childless, also a cause of relationship breakdowns.

According to the Office for National Statistics, women head up nine out of ten lone-parent families; a role that many didn't expect to be thrust into but once again, in the main, appear to

be coping admirably. Being a single parent always seems to have had a stigma, a bit like a second-class citizen and I say that with a passion. Having found myself unexpectedly a single parent four months before the birth of my daughter, I speak from my own personal experience when I say the majority of single parents do a fantastic job and I can think of examples of both men and women. Clearly, in some cultures around the world, the attitude towards single parents varies from abhorrent to accepting and thankfully within the West, the attitude is becoming more liberal to having children in relationships outside marriage.

There are also many cases of celebrity or high-profile women who are choosing to adopt children, keeping their single status, as in the case of *Ally McBeal* star Calista Flockhart who adopted baby Liam, Michelle Pfeiffer who adopted baby Claudia Rose and Diane Keaton. They all did this initially without the support of a male partner. There are other examples of celebrity single mums like Jodie Foster who decided to go it alone from the beginning and women like Nicole Kidman, Angelina Jolie and Michelle Collins who are bringing up children by themselves or sharing the responsibility with their previous partner.

We've looked at women instigating relationship break-ups, starting again later in life and holding down a successful and in some cases highly paid career but, while you can cope with that lot when there's just one of you, can you really have it all when it comes to the extra addition of a family too? While there are many women who struggle to dash from the office to

get home in time for bathtime and then spend the rest of the evening clearing up, only to collapse in a heap at bedtime ready for another gruelling day ahead, equally there are those who have taken time out or given up a high-flying career after having children.

I've also met and interviewed women who've started their own businesses or taken on franchises to enable them to work during the day and also spend time at home with their children. Maybe women really can have it all, if we think ahead and don't leave it all to chance. The women that seem to attract the biggest headlines are always the high-flying career women who give up a six-figure salary to stay at home with their children. Penny Hughes, who I briefly mentioned earlier, was president of Coca-Cola UK and Ireland at 29. By the time she reached her thirties, she gave up her job, said to be earning her around a quarter of a million pounds, to bring up her family. But although she might have left the nine to five job to bring up her family, she didn't completely get out of the rat race. She took on several non-executive directorship roles at companies including Vodafone, Gap and the newspaper publisher Trinity Mirror. Her decision was greeted with mixed feelings; some people praised her for putting her family first while others believed she was letting women down.

I consider myself very lucky in my own career over the last few years as I've had the type of job where I can choose my hours, within reason, and the work I want to do. There were times when in the early days I had to turn down early morning presenting jobs because I just couldn't be leaving the house at

four in the morning when my daughter was younger but equally now there are times when I can organise my job around my life. Yes there are times when I've worked till the wee small hours, more recently in completing this book! But it's about having that flexibility to decide whether to take certain jobs, work certain hours or not which is why, as we've found out earlier in the book, that many women are opting to start their own businesses when the corporate culture doesn't fit.

In closing this chapter I think it's important to realise just how far we've come in our personal lives, first and foremost as your own person but also as wives, partners or mothers which is carried through into our relationships. We're now embracing the single life rather than seeing it as a form of failure, carving out successful careers, particularly in the face of adversity, and refusing to let obstacles like a lack of education hold us back. But having said that it doesn't mean we can get complacent and sit back feeling smug, after all, without your constantly changing dreams, aspirations and hopes for the future, what purpose would there be in life?

chapter 10

WOMEN ON THE INTERNATIONAL STAGE

In the West, when we talk about the corporate culture and the problems of breaking through the glass ceiling, we can often forget that within other cultures of the world women can and do face very different problems in business. Banging your head against the glass ceiling would probably be welcomed in some cultures, where women have yet to even get a foot on the first rung of the career ladder. In countries like Pakistan, India or Kosovo, women probably have more of a fight on their hands simply to step outside the front door unaccompanied every day. In this chapter we'll look at some of the problems women face in trying to establish themselves in business in other cultures around the world and the women that have succeeded on the political stage.

In countries like Pakistan, where women must adhere to a strict moral code as part of their religion and upbringing, it can cause great difficulty when trying to work but, having

said that, Pakistan was the first country in the Muslim world to elect a female prime minister twice. Turkey may sit on the borders of the East and West, but around one quarter of its women are illiterate and make up a minority of the country's paid workforce. Sadly for many women in cultures that, in the West, we might see as oppressive to women, there is still one readily available option to bring in a source of income; prostitution. In Nepal it's such a problem that Anuradha Koirala, known as the Mother Theresa of Nepal, founded an organisation, Maiti Nepal, to rescue girls from the brothels. It's pretty impossible to try and get any accurate figures for the number of girls and young women travelling from Nepal into India to enter the 'profession'. Some families are so poor they often send their daughters to brothels, desperate to secure some form of income. With the average annual wage around US$200, young girls can be paid thousands of dollars for sex.

In many of the Asian countries, it's the male dynasty that the families want and women are secondary to the men in the family – real second-class citizens. They don't stand to inherit property and can arouse suspicion if not under the protection of a man. While in the West we might complain about the problems of getting on in business, for many women in these countries they've yet to even make it to the workplace, unless it's in the form of making handicrafts at home or doing hard labour in the fields.

In Africa's first online newspaper the *Mail and Guardian*, Linda Toussaint, a businesswoman who runs a car import

company, describes the problems that women face trying to get on in business:

> Africa is already a very closed continent for women because of certain customs and norms, which men try to maintain in their homes and in professional circles. A few years ago, people only trusted women to be homemakers and their occupations were pretty much limited to child rearing and taking care of the home.

Toussaint herself started a car import company in 1999, in a country where only 10 per cent of Gabonese businesswomen manage companies in the country. They make up around 5 per cent of chief executives in the country's company boardrooms. Another problem women face in business is securing financial backing; in Gabon there seems to be a real trust problem and women asking for funds can typically expect to get around a quarter of what they need.

In places like Kosovo, it could be argued there's a glimmer of a chance to improve women's rights in a traditionally male-dominated society. In an area where there are heavy burdens on women and they have few privileges, many are now finding for the first time they're the breadwinner yet jobs are not plentiful for women. A lack of education, where previously daughters were kept at home for fear of their safety, has meant that even less women stand a chance of securing more professional roles like teachers, lawyers, journalists or doctors. Things are improving, with, for example, the organisation called Kosovo Women's Initiative, set up with around

ten million dollars from the American government that promotes organisational skills and encourages women to get into the workplace.

Even in the highly developed Western world, some roles have until recently been beyond the grasp of many women. America only appointed its first female commander of navy warships, Kathleen McGrath, at the turn of the millennium. A mother of two, Kathleen McGrath, was the first woman to secure the position, after the rules changed that previously prohibited women serving on warships.

Recently, one of the biggest developments in the business sector in countries like India is the setting up of call centres for large, high-profile, multimillion-pound international companies. According to the *Hindustan Times*, US employers are favouring the English-speaking college graduates of India when it comes to manning their call centres. According to the report, companies including Delta Airlines, American Express, IBM and Hewlett-Packard are tapping into the market and an estimated 400,000 US jobs are believed to have gone overseas to China, India and Russia. With jobs like these, women stand more chance of getting work as a cross-section is needed.

So while we could argue that when it comes to climbing the corporate ladder some women seem to have got stuck on the lower rungs, when it comes to leading countries in the role of prime minister, queen, president and even as the first lady, women the world over haven't done too badly. Within the

world's royal families, there are, and have been, many great female icons: Diana, Princess of Wales is arguably the most famous and obvious choice but Queen Elizabeth II, Princess Grace of Monaco, Jacqueline Bouvier Kennedy Onassis (remembered by many simply as Jackie O) and Middle East first ladies including Suzanne Mubarak, Egypt's first lady and Jordan's Queen Rania Al Abdullah.

When it comes to naming presidents and prime ministers, there's quite a distinguished list: Margaret Thatcher, Indira Gandhi, Benazir Bhutto, Maria Corazon Aquino, the list goes on. First ladies too have made a name for themselves in their own right, not in just playing a supportive role at their husband's side. Before the days when Hillary Clinton emerged as powerful female icon, the Argentinean people had long since been in awe of Eva Peron, Evita, the wife of former Argentine President Juan Peron, who made her name in a role quite unprecedented in Argentine politics. Evita became a high-profile and active campaigner for the poorer classes – pushing for higher wages and visiting factories and hospitals to meet the very people she was trying to help. She was a woman able to relate to people and establish a natural rapport, a role that Diana, Princess of Wales, remembered by many as 'the people's princess', also established as her own. Evita's quest to help the suffering underclasses didn't endear her to Argentina's elite, but when she died in her early thirties there was unprecedented public grief across Argentina. Evita's story has been the subject of both musical and film and ironically her role was played by another world female icon, Madonna, in the film version.

First ladies like Hillary Clinton never seemed content to sit on the sidelines. Some would argue it was never a case of her being first lady but more of a co-president. When her husband stepped out of the limelight, Hillary Clinton seemed to move onwards and upwards, winning the New York Senate race and many speculate that could one day run for president. Look at Tony Blair, Britain's Labour prime minister, whose wife Cherie has a very high-flying career in the legal world. The British papers have certainly been full of speculation as to whether Blair will stand down to enable Cherie to further pursue her legal career or put his career first and consider standing for another term. Even if this is nothing more than speculation, the very fact that it's an issue that's been aired or at least considered by the press is telling of the way society has changed. Once the role of a traditional male prime minister or male president's wife would have been that of a supportive partner, now many have earned respect in their own right. Suzanne Mubarak, Egypt's first lady, is known for her influence on women's rights where the country changed its divorce laws and Queen Rania of Jordan is seen by many as a champion for women's rights, with her criticism of 'honour killings', where it's the custom for men to murder female relatives if they've committed adultery or lost their virginity before marriage. Earlier this year Queen Rania launched a high-profile media campaign aiming to change some of the stereotypes affecting Arab women.

Let's take a look at the women who've held international political leadership roles. In some countries where it could be

argued women are traditionally oppressed and find it hard to achieve any form of equal footing with men, there have been several female world leaders from those very areas, for example across Southern Asia.

The first female prime minister was Sirimavo Bandaranaike who took office in Ceylon, now Sri Lanka, in 1960. Politics was never believed to be her lifelong ambition but the ambition in fact of her husband, who was assassinated when prime minister in 1959. Sirimavo Bandaranaike entered politics after his death where she took over the running of the country, leaving office five years later.

Maria Corazon Aquino of the Philippines was asked by the opposition to contest the 1986 presidential election, after her husband was assassinated in the early 1980s at Manila airport after three years in exile in the US. She stood for one term from 1986 but stood down in 1992.

Benazir Bhutto of Pakistan served as prime minister of Pakistan during the late 1980s and again for a further three years in 1993. She was the first female leader of a Moslem country in the modern world. Her father was once the prime minister of Pakistan but after the military assumed power, he was later hung. Benazir Bhutto herself was detained by the military regime and finally allowed to leave Pakistan, where she settled in London before returning to become prime minister in 1986. I found an interesting quote from Benazir Bhutto on a BBC World Service website which really proves that women throughout the world – whatever their position in

society, whatever their cultural background – are all struggling with this concept of whether it's possible to have it all. She says:

> When I was growing up I thought a woman could have it all and now I find that yes a woman can have it all but she has to be prepared to pay the price. And the price means a lot of guilt about not being there for your children when they need you, a lot of tension also with your husband on work schedules. So you find you can have a husband, you can have a family, you can have a career but at the end of the time you have very little time left for yourself. That's a choice I made and it brought me a lot of satisfaction but for those who want to start out, I would say there is a price that has to be paid.

The examples I've highlighted are just a few of the world's female leaders, but in some cases there's a pattern emerging, whereby some of them have gained office or been elected after their husbands or other family members were assassinated. One school of thought is that it could be a wave of sympathy that swept these women to power but I still think it's interesting and yet ironic that in nations of the world where women may be held back at home they can still secure the country's top jobs.

There's also this element of needing to draw on your inner reserves of strength in order to be able to cope with the situation when you've been thrust into the spotlight through circumstance rather than choice. That's when I believe that

women's true inner strength really comes to the fore and in some cases that they can release their true potential. We appear to be adept at taking situations not of our own making but turning them round and making the best of them. These issues can be in the form of unexpected redundancy or a relationship break-up. On a wider scale, look at some of the issues that Diana, Princess of Wales faced during her marriage. Whichever side you take and whether you believe that she was able to manipulate the media, she certainly didn't have an easy time once the palace doors closed behind her. Who knows, if she had had a much easier ride within the palace walls and a truly happy marriage to fall back on, would she have pushed herself forward into the spotlight or been more content to play a supporting role to Charles? After all, in the early days, wasn't it us, the 'adoring' public, who pushed her into overtaking Charles in the popularity stakes? Remember the days of Di-mania, when it seemed every woman had that hairstyle and on an early walkabout even Charles was heard to complain that the masses only seemed interested in his new wife? When it comes to being in the spotlight through circumstance, there's also the example of Queen Elizabeth II; in her early life there was never really any expectation of her being queen until an unexpected turn of events, the abdication of Edward VIII, led her father to become king and placed the young Elizabeth firmly and squarely in line to the throne.

When it comes to the way women rule, it's interesting to see that we don't necessarily have to sacrifice their female traits to be become powerful and successful. Baroness Thatcher,

Britain's first female prime minister came to power in 1979 for an 11-year rule, the longest prime minister's reign for over 150 years and she took on the job the other side of 50. The so-called Iron Lady may have inherited her love of politics from her father but in fact it's her mother who's credited with giving her the juggling skills needed to play the roles of wife, mother, politician and later prime minister. In Brenda Maddox's biography *Maggie The First Lady*, she quotes from Margaret Thatcher's own memoirs in which she credits her mother with teaching her and instilling in her a great ability to organise and juggle so many facets of her life (Maddox, 2003). Her mother combined household duties with running the family shop and entertaining, in her capacity as mayoress of Grantham, and Baroness Thatcher had a marriage and two children, thus combining family life with a political career.

She may have earned herself the title of Iron Lady for her political stance but, on a more personal level, those who knew her claimed that she had a much softer and more feminine image. Much has been written about the fact that she much preferred the company of men to women and she certainly had a soft spot for many male colleagues including, some say, Cecil Parkinson, but far from sacrificing her sexuality, it could be argued that using her female charms was one of her great talents. She's been photographed by the world's media in 'homely' roles including cooking the family breakfast and just think about how many times you've ever seen her sporting a trouser suit or without that ever-present handbag at her side. Pretty rare, if ever? There's a lovely image in Brenda Maddox's biography of Baroness Thatcher where she is doing

an interview for *Woman's Own* during the 1970s, when she was very much the new girl on the political stage. At the end of the interview, Margaret Thatcher apparently started asking the magazine editor about how she managed to do her hair in a particular style and later agreed to having a makeover, courtesy of the same magazine.

While in many countries the subject of the number of women getting to the boardroom rumbles on, in Norway they're ensuring women have more of an equal footing in both business and government. The Norwegian Minister of Children and Family Affairs Laila Daavoey has introduced strict targets for the number of women holding down boardroom positions in state-owned and public-owned companies. If targets aren't met, companies could face strict legislation to enforce it.

From January 2004, the boards of every state-owned company should have a minimum 40 per cent representation for each gender. It's the same situation for public companies but provided a 40 per cent level is achieved by September 2005, laws will not be enforced. Laila Daavoey says going back just over ten years in July 1993 only just over 8 per cent of board members in public joint stock companies were women. The balance even extends to politics, she says:

> Most political parties practice an informal rule on having a minimum of 40 per cent representation of each gender among their representatives in the Parliament, but only a few parties fulfil this aim.

However the current Parliament consists of 37 per cent of women and 63 per cent of men. In the UK, numbers have risen and fallen; numbers were particularly low after Margaret Thatcher came to power but after the general election of 1997, over 100 female MPs were elected.

Referring back to Norway, I'd argue that surely as a woman you'd want to be given any job on your own merit rather than because the government decided a fairer representation of the sexes was necessary? After all, what's to stop companies who are in the position of *having* to recruit women to fill the positions not necessarily finding the best person for the job? On the other hand, are all those men filling up corporate positions really the best people to do their jobs or just the knock-on effect of the old boys' network? So it works both ways. I'm in favour of anything that gives men and women an equal footing, so if in some countries or companies women are still not getting the opportunities or openings to prove their true potential, then surely a helping hand in the form of the government can't be a bad thing? Minister Laila Daavoey says:

> In view of women's high standard of education and rate of employment, it is paradoxical that there are still so few women in top management positions in the business sector. Different surveys have found that many women experience a so-called glass ceiling, which makes it hard for women to reach top leadership positions. Today men in reality are recruiting other men into executive positions and boards. And it is still women who are taking the greatest responsibility for home and family.

While we're on the subject of home and family, let's look at marriage for a minute. In some parts of the world women advertise themselves through agencies or magazines in order to find a foreign husband, someone who can take them away from the plight of their own country and as it would seem there are enough willing Western volunteers, it can be a growing and successful business. But when men marry outside their culture or country, in some cases it can result in a large population of single women, which is frowned upon in some societies.

In some countries this is causing the authorities real problems, so much so that in the United Arab Emirates (UAE) in 1994 the authorities set up a 'marriage fund' to encourage Emirati men to marry local women rather than foreign women. The rising trend in the number of Emirati men marrying foreign women is believed to have come about because of the potentially prohibitive cost of a traditional wedding plus the dowry that's usually provided by the groom. It's often cheaper to marry a foreign woman and with many Emirati women now much better educated, they may be less willing to settle down into the traditional role of an Emirati wife.

Bearing in mind this is a culture where being unmarried past your mid-twenties is pretty much a case of being 'left on the shelf', the number of single women has been causing concern for the authorities. As part of the marriage fund grants of around the equivalent of ten thousand pounds per couple are available. The setting up of this marriage fund is believed to have eased the situation somewhat but it's not totally stamped out the problem.

In looking at other cultures within other countries of the world I think there are several issues that come up the world over. Interesting that when I spoke to Jamila Ibrohim, a truly remarkable woman, who is head of the delegation for the International Federation of the Red Cross and Red Crescent societies in Afghanistan, with all her experience of living in and working in cultures around the world, she too raised many of the same issues that women had raised in more Western countries or even in the workplace.

Jamila trained as a theatre nurse before deciding to work overseas. She has since worked in countries including Pakistan, Afghanistan, Cambodia, Sierra Leone, northern Kenya, Tadjikistan and Angola. She says being female has never really been an issue:

> I think gender is often overplayed. Most people I've come across respect you because you're good at your job. I guess I've always accepted that as a woman you've got to work twice as hard to get to the same place; it's something I've never really thought about but just accepted.

Earlier we looked at how some female world leaders have come to power on the back of crises which included the assassination of their husbands or family but went on to lead their country. Having worked in many countries particularly within the developing world, Jamila says this is a crucial and fundamental aspect of a woman's character that she's witnessed time and time again:

Women are much better able than men to deal with crises. In the Islamic world you hear a lot about the oppression of women but if you look at women within the home in these societies they're very much the leaders, they're responsible for the health and welfare of their family. They may have a very difficult life and they have lots of children to look after but they have this inbuilt training, if you like, that they inherit from their own mothers and aunts so they can take on the leadership role at home.

She believes you can never underestimate how hard women are prepared to work: 'they're the ones working out in the fields, doing the manual work, taking decisions and they're just so inspiring'. And inspiring we may be but do we always get recognition for this work, particularly when in some cases it involves risking our lives? When the tragic events of September 11 unfolded, the New York fire department was at its very centre when it came to being on hand to cope with the emergency and the horrific aftermath. I remember reading that out of nearly 12,000 fire fighters in the force, around twenty-five were women.

One aspect Jamila feels strongly about and says we tend not to see on the TV news or read about in the papers is how many women, particularly in areas like Afghanistan, are trying to rebuild their lives by starting their own businesses:

There are many women going into business, starting local bakeries, local enterprises – there's a huge number of widows in Kabul and women are assisting other women in

these roles and in their attempts to rebuild their lives. But it's the culture within these countries that doesn't always let these aspects of their lives come to the fore.

She says the women in these cultures are very strong and a great source of inspiration to other women:

> Strip away some of the cultural and traditional aspects and you'll find everywhere that women are very strong; they have a great strength of character.

Maybe in some cases the problem is our perception with what oppression means and in how the media portray women around the world. Look at countries where it could appear to those on the outside that women are oppressed, for example in the Middle East where women often dress in head to toe in black abayas, yet in a country like Bahrain, where only a few years ago women were allowed to vote, they've now appointed a woman to the board of the Bahraini Chamber of Commerce and Industry.

Mona Yousuf Al Moayyed was the first woman to elected to the board and is fast becoming one of the regions' role models. There's an increase in the number of women's business networks across the Middle East, often with the blessing of Arab first ladies, such as Suzanne Mubarak of Egypt and Queen Rania in Jordan who have both been outspoken on women's issues.

Jamila herself has converted to the Islamic faith, which, although she says wasn't a conscious decision towards

acceptance by the local Islamic people, has naturally brought her much closer to them. Interestingly she says when it comes to religion there is no differentiation between men and women – she says she's viewed first and foremost as a Muslim which is more important than the fact she's female or English.

Back to the old boys' network which seems to be alive, well and kicking in pretty much any culture. I've highlighted the situation in Norway and how the government are putting pressure on companies to increase female representation in the workforce, but Jamila believes the problem of getting recruited past the men is an issue which can occur the world over within any organisation:

> I've come across people who are more interested in prolonging their own career and in promoting people who are not always the best people for the jobs. At the end of the day whether you're a man or a woman people respect you for getting the job done, you don't earn respect down the pub on a Friday night.

The emphasis that different cultures place on family life is interesting. In some countries or even some workplaces, you'd be hard pushed to be able to get a day off work because of a family funeral – it would probably be seen as 'inconvenient' – whereas in other cultures family will always comes first. I remember being told in Dubai that's it's not uncommon for someone to cancel a business meeting because they've got to collect a family member from the airport or have a personal

matter to attend to. This is further illustrated when it comes to the subject of how quickly family will crop up in any conversation. In Pakistan Jamila says:

> One of the first questions women always ask you is how many children you've got and because I don't have any children they always view that as very sad because to them family is the most important thing.

I remember Penny Streeter, the founder and managing director of the recruitment agency Ambition 24 Hours, who I interviewed for an earlier chapter, telling me that when you get women together they'll very often and usually very quickly talk about their kids:

> They'll ask about childcare; how you mange or who is looking after your children but if you go to a meeting where the chief executive is male you wouldn't start asking him about his childcare arrangements.

When it comes down to leadership skills, another aspect of the difference between the way men and women lead comes up the world over. It's the fact that women seem able to lead without ego and are open to discussion; it's not a case of making a decision and sticking rigidly to it. As women have said themselves earlier in the book, they're not afraid to ask for help and don't view asking for help and advice as a weakness. Take the situation Jamila found herself in while working in Pakistan. She says she's always adopted a team method of working, 'maybe it's because of my nursing where

you're heavily dependent on the other people in the team', but in leading her own team she's always favoured an open door policy where issues can be discussed:

> In Pakistan that goes against what they're used to; they've been used to a fairly hierarchical and bureaucratic way of working.

Her philosophy is that she's there to get the job done, not to empire build:

> I find the macho culture very interesting. I'm not the slightest bit interested in the power – I don't feel a personal ownership of what I'm doing – so for me it's very easy to hand over a project to someone and put all my energies into the next task. Although women sometimes seem to have this image of being softer or more touchy feely, I'd like to think I'm 'firm but fair'. I've often found men of a certain age around 50 plus definitely do like their little empire ownership.

She believes that men who adopt this attitude often find it much harder to hand over projects to someone else, whereas she says she's able to do this because she truly believes in the Red Cross:

> It's not just about Jamila Ibrohim, it's a team that was led by Jamila Ibrohim for a period of time which is now being led by somebody else and hopefully will continue to do good work.

chapter 11

SIMPLY THE BEST

You know how when you've read some books, you think, 'oh that was interesting', put the book down and think nothing more about it? Well in ending this book I didn't want it to be the sort of thing you leave lying under the bed, stuffed in a cupboard or rediscovered five years later in a box of odds and ends. I wanted it to be an inspirational book and to offer everyone something that was relevant to their own lives. Clearly, depending on your own personal situation, whether you're working or not, married, have children, in a relationship or where you live in the world, your circumstances will be so totally different from other women, (and men) reading the book, so I've tried to include some really inspirational quotes and advice from women in this last chapter.

I hope that it's a chapter you can pick up time and time again, maybe at different stages in your life to get further inspiration from some of the women whose experiences may not be relevant to you right now at this stage but could become relevant further down the line.

Some of the women who feature in this last chapter we've met before in the book; others we meet for the first time but I hope their advice and perception will help you to achieve whatever goals you have still to conquer in life.

Carol Pudsey Marine geologist with the British Antarctic Survey

Carol has been making expeditions to Antarctica for nearly 20 years with the BAS. Her longest trips have taken her away from home for up to four months and she's managed projects with teams of up to 20 people.

> I did maths, physics and chemistry for A-level and when I was a kid doing science nobody ever said, 'you can't do that, you're a girl!' I've never really thought of myself as a female scientist, I'm a scientist that happens to be female. When it comes to leadership skills, I think you've got to have a genuine interest in your troops and really care about them as people. One of the best role models I worked with was one of my captains, although he wasn't a particularly demonstrative person you could tell he really cared about his ship and about us but in a strong but quiet way.

Priscilla Vacassin Human resources director – Abbey

Priscilla Vacassin joined Abbey as the human resources director in June 2003. She was previously group human resources director at BAA plc and had previously spent ten years with the Kingfisher Group. Priscilla spent four years bringing up her two young children before embarking upon

her career with United Biscuits in 1985. She is a widow and has two grown up sons.

Don't be afraid to be yourself. I think women are very good at creating conditions within which people can be successful and that means using skills that people don't always feel comfortable with in the workplace. Like being a good coach, being a good facilitator, being collaborative and in certain areas that's still seen as being 'weak', or not competitive enough. I would say to women 'don't be afraid to use your tough side as well as your facilitating side because that's where the real strength lies, in the balance of being able to support the organisation and the people in it but also being able to challenge the organisation and people in it and bringing both of those strengths together is the greatest single strength women bring to an organisation.

I think women who feel they just have to bring the tough side of themselves and start aping male behaviour do themselves as well as everyone a disservice. It's a balance of being challenging and supportive that is the unique thing you get in women.

Fiona Bruce Solicitor and founder of Fiona Bruce & Co Solicitors

Fiona is married with two young children. She set up her own law firm 15 years ago and now has over 30 staff. Although the business has now won her several awards, she started off making calls from public telephone boxes and continued working while still recovering from a major car crash.

Women need more confidence whereas men are generally not short on confidence. Believe in yourself, you have such a lot more to offer than you might ever have sat down and recognised.

Janet Paraskeva Chief executive of the Law Society

The Law Society is the representative body for solicitors across England and Wales representing over 100,000 solicitors. Prior to her appointment to the Law Society in 2000, Janet was director for England of the National Lottery Charities Board and has also served as a magistrate.

We've become more used to seeing male leaders as being forceful and directive and when a woman is being forceful and directive we tend to say she's behaving like a man. She's not, she's being forceful and directive. Likewise when men demonstrate some of the characteristics I believe are inherent of a good leader like looking after your staff, quite often skills that are described as softer and caring skills, we say, 'he's showing his feminine side'. It's bizarre that we've decided to label things in this way and I think it's a bit sad really; it tends to further lock men and women into these stereotypes that are used to define them. Women are really bad at seeking recognition and really underestimate their abilities; men find it so much easier to say what they're good at; what we tend to do is say what we're not so good at and I think we've got to learn ways of being proud of the things we do well and come out and say that.

Nicci Holliday Senior manager with the BBC

Nicci worked for BBC local radio before heading into London to work on special projects for BBC Nations and Regions.

I think you need a cool head and the ability to prioritise. The world around us expects us to be able to do everything and we expect even more of ourselves. I've found simply by making lists, learning to say no (constructively) and taking advice and sharing my workload with colleagues it reduces the pressure I feel. I've also found that you need to build in 'me time' and if that means working from home, or taking Monday afternoon off, then that's OK. We know what we need to do and our deadlines and should be able to judge how we do that and not feel restricted to work nine to five. This 'me time' has made me much more constructive when I go back into the office. I find that I'm a much better leader as I demonstrate how to be effective, get things done and still have a life! I make sure the team that works with me lives the same values and I expect no more. I'm not just a suit, I'm a real person.

Margaret Draper Co-chair of the marketing communications committee, Financial Women's Association based in New York

The Financial Women's Association was set up in 1956 with the aim of shaping leaders in business and finance with special emphasis on the role of women.

Women don't have to outdo men; they have to act professionally but they don't have to hide their personality, they don't need to change their personality to succeed.

For women it's about juggling and offsetting priorities, women need to be extremely well organised and have a support network around them. They need to learn how to network, how to find good mentors and how to be mentors to other women and men using organisational and human relations skills in the workforce.

Jane Wenham-Jones Author and broadcaster

Jane Wenham-Jones is the author of two novels, *Raising The Roof* and *Perfect Alibis*. She's published over 100 short stories and features in both the women's magazines and the national press. She now gives talks and workshops and is regularly booked as a humorous after-dinner speaker. Her motto is never pass up an opportunity to be the centre of attention.

I keep a quote from Goethe stuck to my computer – 'Be bold and mighty forces will come to your aid'. If you really want to achieve something, then go for it. And don't let anyone put you off. It took me 18 months to sell my first novel, *Raising the Roof*. One agent told me it was unpublishable. I got close to despair at times but it never occurred to me to give up. Now I have just finished my third. In the beginning, I said yes to everything even if that meant spreading myself thinly, or a four am panic after spilling the beans on a tacky TV show. It's amazing how one thing will lead to another – a simple interview in a local paper can

lead to interest from a national or an appearance on television. Network, network! Nothing is wasted. Everything is an opportunity.

Alison Sharman BBC daytime controller

Alison has been the controller of daytime programmes at the BBC since January 2002. She started her career as a BBC secretary on the consumer affairs programme *Watchdog* before becoming a series producer. She's worked at BskyB, TV-am and made programmes for Channel 4. Alison is a working mother with two young children.

> I believe hugely in investing in talent – when you find talented people you invest in them. You invest in women and you invest in men and that mentoring of people, of being the role model, is hugely important. When I've worked with, or alongside somebody, I've looked at them and the qualities they have and I try to bring the best of all qualities of people that I think have shaped and made a difference and bring them into my management style.

Anita Loewe Chief executive of Venues Unlimited

Anita set up her hotel and conference-booking agency along with her husband 15 years ago from the bedroom of their cottage. They rapidly expanded and now employ over 60 people. Prior to starting the company, Anita had over ten years experience in a senior capacity for an international hotel group.

When I think of various roles I've been in like president of the Chamber of Commerce where the council were made up from 19 men, it's always important to gain respect. You've got to work to earn respect – that's always been a key philosophy for me – you can't expect it to be given to you, you must earn it.

And you should enjoy being part of a team; remember you're only as good as your team whether that team is your company or a smaller team within a company.

Philippa Stephen-Martin Founder of Cbabiesafe

Philippa launched her company in April 2002. Her unique nursery means working parents can check on their children via a secure webcam site. She's a single mother to Mia and the winner of the Natwest Everywoman Award 2003.

We've all got people in our lives who we think of as our friends but you should never listen to too many people. Friends can worry about you but if you listen to the views of too many people you can end up feeling negative yourself. If you really really believe in it you can do it. When I moved into my house to start my business, I had £80 in my pocket and the mortgage was over £3000 a month. If I'd taken any notice of what other people had said I probably wouldn't be where I am today, despite the fact it's cost me a lot of money over the years I'm where I want to be and running a business that's taking in over a quarter of a million pounds a year.

Penny Streeter Founder and managing director of Ambition 24 Hours

Penny's a working mother who, after losing one business and finding herself and her family in homeless accommodation, created and built up her business. Ambition 24 Hours is an agency specialising in supply qualified healthcare professionals.

> Don't ever be put off by the fact that you're a woman. There's a level playing field out there and if there's not one in your particular sector they have to create it.

> Have absolute real determination and research whatever you do. Be prepared to work very very hard, a lot of people who open businesses have a very good idea but plan on it working within a year. I'd say for a business to produce a return of any kind of income it's going to take you at least three years. It's a long-term plan.

Maxine Benson Co-founder and director of Everywoman (www.everywoman.co.uk)

With a career in the airline and film industries, Maxine and her co-founder Karen Gill founded the organisation as a one-stop shop for giving advice, help and support for women starting out in business.

> I believe many women make great leaders because they tend to do things more by consensus. They hear more things, they hear other people's opinions and listen to them before a decision is made. I think because they often find themselves taking responsibility for other things in life, like

children, elderly parents, their home, as well as a career, I think they have a broader view of the responsibilities and pressures that life brings and I think once you have that understanding that has the potential to make you a great leader.

Sally Preston Founder of Babylicious

Babylicious is the brainchild of Sally Preston. The company produces home-cooked baby food for an international market. After spending her earlier career in the corporate world, Sally started her business after going through a traumatic divorce, becoming a single mother and suffering from skin cancer. Sally now lives with her partner and two children.

Always ask for advice; you don't necessarily have to take it, but the fact you've asked for an angle, a viewpoint, a contribution, that's definitely a positive thing.

I think the second thing is not to lose touch with reality, because I think in business you can get up your own arse a bit really and I think you can begin to lose the plot.

I think the way of avoiding doing that is to make sure you have time for your family and time for your friends because that puts you back into touch with reality. When you're running your own business you can lose your grip; you get very insular and can't see the wood for the trees.

bibliography

Chapter 1 – Where to Begin?

Quote from *My Fair Lady,* 1964 film starring Rex Harrison and Audrey Hepburn.

Men Are From Mars, Women Are From Venus – John Gray – http://www.marsvenus.com/JohnGrayProfile.php – Profile of John Gray.

The Proper Care and Feeding of Husbands – Dr Laura Schlessinger published 2004 by HarperCollins. Reviewed in the *Daily Express* Monday 22nd March 2004 by Jane Fryer.

Research into the differences between the male and female brains. Professor Simon Baron-Cohen Director, Autism Research Centre at the University of Cambridge – http://www.admin.cam.ac.uk/news/press/dpp/2004030501.

Research by Cranfield University School of Management – *The Female FTSE Report 2003* by Dr Val Singh and Professor Susan Vinnicombe.

Chapter 2 – The Changing Role of Women

Figures for marriage statistics – from the Population Reference Bureau, Washington DC, USA – http://www.prb.org/Content/NavigationMenu/PRB/Educators/Human_Population/Population_Growth/Population_Growth.htm.

True Love Waits Programme – http://www.truelovewaits.org.za/faq.php.

Egyptian History – *Egypt and The Sudan* – Scott Wayne published 1990 by Lonely Planet publications – http://www.bbc.co.uk/history/ancient/egyptians/

Figures for female circumcision from BBC news report 23rd December 1998 – http://news.bbc.co.uk/1/hi/health/medical_notes/241221.stm.

Research on family life by the Future Foundation – http://www.futurefoundation.net/.

Chapter 3 – Boardroom Women: Breaking Through the Glass Ceiling

Research by Cranfield University School of Management – *The Female FTSE Report 2003* by Dr Val Singh and Professor Susan Vinnicombe.

Speech by Niall FitzGerald KBE of Unilever supplied by Unilever. Speech made at the conference Women in Leadership; A European Business Imperative in Geneva June 2003.

Chapter 4 – How Will Men Cope?

Figures for the number of stay-at-home fathers from HomeDad – www. HomeDad.org.uk.

Nicholson McBride – largest independent business psychology group in Europe – http://www.nicholson-mcbride.com/uk/.

Navigator Course – media comments in article in *Guardian* newspaper 26 May 1999 – http://www.guardian.co.uk/Archive/Article/0,4273,3868673, 00.html.

Details of the Navigator Men's Development Programme Course – http://www.navigator-network.com/.

Comment by the author Marian Keyes in an article in the *Guardian* newspaper – 26th September 2002 – http://books.guardian.co.uk/departments/ politicsphilosophyandsociety/story/0,6000,799305,00.html.

Quote by Margaret Thatcher taken from BBC News website report on 26th June 2003 – http://news.bbc.co.uk/1/hi/uk_politics/2992206.stm.

Comments by Val Williams taken from her website – http://www.valwilliams. com/about.html.

Chapter 5 – Workplace Skills

Report by the Chartered Institute of Personnel and Development (CIPD) *Living To Work?* published 10th October 2003.

Chapter 6 – Women in the Heart of the City: The Money Markets

Clara Furse – Chief Executive of the London Stock Exchange – press release supplied by London Stock Exchange dated 24th January 2001.

Research on private investors supplied by www.DigitalLook.com.

Research from Babson College, US – *Mutual Fund Managers: Does Gender Matter?* by Richard T. Bliss and Mark E. Potter.

Investment Clubs – Julie Ralston – http://www.network.auroravoice.com/ finance.asp.

bibliography

Chapter 7 – Sisters are Doing It for Themselves

Background information on Babylicious – Sally Preston www.babylicious.co.uk.

Background on Ambition 24 Hours – Penny Streeter – www.ambition24hours.co.uk.

Background on Everywoman – Maxine Benson – www.everywoman.co.uk.

Chapter 8 – Women in the Media

Yvonne Ridley – http://media.guardian.co.uk/attack/story/0,1301,566065,00.html.

Reference to Buthaina al-Nasr – details from BBC News 12th January 2004 – http://news.bbc.co.uk/1/hi/world/middle_east/3389923.stm.

Background on Barbara Walters – http://www.goodmanspeakersbureau.com/biographies/walters_barbara.htm.

Biographical material on BBC Executives – Lorraine Heggessey, Alison Sharman and Jana Bennett from www.bbc.co.uk/pressoffice/biographies.

Chapter 9 – Who Wears the Trousers? Women in Relationships

Neil Armstrong quote taken from BBC news website – http://news.bbc.co.uk/onthisday/hi/dates/stories/july/21/newsid_2635000/2635845.stm.

Reference to 'Home Alone' broadcast August 2003. www.kenanmalik.com/tv/analysis_singleton.html.

Reference to number of single women in property market – http://news.bbc.co.uk/1/hi/business/2525561.stm.

Reference to Nicole Kidman – http://news.bbc.co.uk/1/hi/in_depth/entertainment/2002/oscars_2002/1768843.stm.

Reference to effect of relationships on men and women – http://www.ananova.com/news/story/sm_849244.html?menu=news.surveys.

Financial Women's Association – http://www.fwa.org/aboutus/history.htm.

Reference to Sally Krawcheck – http://www.womenandco.com/womenandco/homepage/forbes.htm.

http://www.forbes.com/2003/10/16/cx_is_1016cwomenqanda_print.html.

Chapter 10 – Women on the International Stage

Reference to *Maggie The First Lady* by Brenda Maddox published 2003 by Hodder & Stoughton.

Reference to Hillary Clinton – http://clinton.senate.gov/about_hrc.html.

Reference to Golda Meir – Israel's 'Iron Lady' – http://news.bbc.co.uk/1/hi/events/israel_at_50/profiles/81288.stm.

Benazir Bhutto quote taken from BBC World Service – http://www.bbc.co.uk/worldservice/people/features/wiwp/dyncon/bhutto.shtml.

index

A

Abbey 71–2, 76, 171
ABC 117
ABC Cable Networks Group 115
ABC Radio 30
Adie, Kate 116, 120–22
Afghanistan 164–5
AFL-CIO 52
Africa 21, 152
Al-Ikbariya 117
Al Moayyed, Mona Yousuf 166
al-Nasr, Buthaina 117
alcohol 10–11
Ally McBeal 148
alpha male population 56
Amanpour, Christiane 117
Ambition 24 Hours 101, 106, 168, 178
America *see* United States
American Express 154
American Navy warships 154
ancient Egypt 3, 18–19
Anderson, Pamela 129
Aniston, Jennifer 116
Annenberg Public Policy Center 115
Antarctica 80, 171
Aquino, Maria Corazon 155, 157
Argentina 155
Armstrong, Neil 131
Asia 21, 152, 157
assertiveness 59–60
AT&T 63, 144
Aurora 89
Australia 2, 8, 29–30, 59, 132
Austria 18
average working week 65–6
Ayers Rock 8

B

BAA 72, 171
Babylicious 100–101, 104, 110, 113, 179

backpacking 7
Bahrain 166
Bahraini Chamber of Commerce and Industry 166
balance of power 43
ballbreakers 13
Bandaranaike, Sirimavo 157
Baroness Hogg 14
Bashir, Martin 125
battleaxe 27
Baywatch 129
BBC 6, 21, 96, 115–16, 118, 120–24, 127, 134, 157, 174, 176
Beardstown Ladies 89
Beckham, David 54
Beckham, Victoria 100
Begley, Charlene 38–9
Benson, Maxine 108–12, 178–9
Berry, Halle 116
Bhutto, Benazir 155, 157–8
Big Brother 128–9
Black, Carole 116
Black, Susan 44
Blair, Cherie 22, 156
Blair, Tony 156
Bliss, Richard 88
boardroom women 28–48
body language 78
Body Shop 13, 16, 39
'Bond' girls 115
bonding 11, 50
Bouvier Kennedy Onassis, Jacqueline 155
Branson, Richard 26–7
breadwinner 25, 55, 131, 133, 153
Bridget Jones 133
British Antarctic Survey 80–1, 171
British Telecom 87
broadcasting 114
Bruce, Fiona 73–6, 78–9, 82, 95, 172
building pyramids 3

bull in a china shop 90
bullying 84
burdens 153
burnout 11–12
business environment 15
Business Week 38, 144

C

Cable & Wireless 87
call centres 154
Cambridge University 9
Canada 2, 30, 34, 43–4, 117, 140
Caputo, Lisa 144
caring professions 28
Cassani, Barbara 11
Castaway 118, 129
casual sex 111
Catalyst Canada 44
catch-22 40, 109
Cavender, Nick 55–8
Cbabiesafe 25, 177
CBI Entrepreneur of the Year 101
Centre for Developing Women Business Leaders 14, 32
changing role of women 13–27
Charcol 135
charisma 47
Charles II 134
Chartered Institute of Personnel and Development 66
Chavez-Thompson, Linda 52–3
childcare 31, 40, 51, 54, 56, 58, 136
Childline 129
China 15, 116, 154
Clark, Elizabeth 67–9, 77–8
Cleopatra 19–20
Clinton, Hillary 155–6
clubbing 139
CNN 117
Coca-Cola 13, 143, 149
Collins, Michelle 148

comfort zone 104
communication 15, 32, 51, 76–7, 81
competition 99
complacency 150
confidence 10–11, 14, 60, 76, 144
Conservative Party 61, 74
control-style management 71
Cooper, Cary 70–3, 76–7, 82
corporate hierarchy 37, 82
Corus Entertainment Inc. 34, 43
cosmetic surgery 17
Cosmopolitan 22
Cranfield School of Management 11, 14, 32
Cruise, Tom 137
cultural differences 15–17, 163–7

D

Daavoey, Laila 42–3, 161–2
Datamonitor 25
Daycare Trust 31
Delta Airlines 154
demarcation 63
Denmark 18
depression 130
Destini Fiona Price 91
Di-mania 159
Diana, Princess of Wales 125, 155, 159
difference in management styles 70–71, 168
different leadership skills 7
Digital Look 86–8
dinosaurs 27
discrimination 84
Disney Channel Worldwide 115
disposable consumer society 140
disposable income 17

divorce 20–1, 61, 99, 103, 133, 136, 138, 140, 156, 179
dot com companies 87
downsizing 28, 63
dowry 163
Draper, Margaret 142–3, 174–5
Duke of Edinburgh 61

E

East End 30
Edward VIII 159
ego 49, 82, 93, 96, 168
Egypt 20, 155, 166
Emery, Linda 36–7
equality 35, 64, 118
escort agencies 146
Ethical Investment Research Service 42, 44
Europe 14, 52
European Union 17
Everywoman.co.uk 108, 110, 177
expertise 62
eye contact 69, 77–8

F

Fast Track 52–3
female circumcision 21
female millionaires 25
female psyche 9
female ratio targets 3, 161–2
female survival skills 98
Fielding, Helen 133
Financial Post 43
Financial Women's Association 142, 174
Fiona Bruce & Co. Solicitors 73, 172
Fiorina, Carly 13, 144
FitzGerald, Niall 34–5, 44, 48
flexibility 79, 94, 111, 150
flirting 67–70
Flockhart, Calista 148
Flora 34
'fluff' factor 115
flukes 47
Fortune 85, 143
Foster, Jodie 115, 148

Fox Entertainment 115
France 100
FTSE 100 11, 14, 32, 86–8
Furse, Clara 13, 84–5
Future Foundation 24

G

Gabon 153
Gandhi, Indira 155
Gap 149
GE Transportation Systems 38–9
gender difference 89, 132
General Electric 38
Germany 2, 18
Gill, Karen 108, 178
girl power 39, 131
girlie nights out 139
glass ceiling 3–5, 27, 29, 34, 48–9, 54–5, 76, 96, 151
Globe and Mail 43
Goddard, Trisha 129–30
Goethe, Johann Wolfgang von 175
Golden Globe 137
Goodwin, Yvonne 95
government 4
Grant, Hugh 115
Grant Thornton 2, 30
Guerrin, Orla 116
gut feeling 90
Gwynne, Nell 134

H

Harpers & Queen 92
Harvard University 63
Hawn, Goldie 116
headhunting 14
Heggessey, Lorraine 122
hepatitis B 129
Hewlett-Packard 13, 144, 154
high-flyers 60, 149, 156
Hiller, Janice 20–1, 23
Hilsum, Lindsey 117
Hindu culture 15
Hindustan Times 154
hitting the 'big time' 146
Hoberman, Brent 45–6
Holiday Inn 62
Holland, Lisa 117
Holliday, Nicci 174

Hollywood marriages 20
Home Alone 134
HomeDad.org.uk 54–5
'honour killings' 156
Horlick, Nicola 38, 53
hormones 22
househusbands 51
how men will cope 49–64
HSBC Start-up Stars Award 100, 110
Hughes, Penny 13, 143, 149
Hurley, Liz 115

I

IBM 154
Ibrohim, Jamila 164–9
IFA Woman of the Year Award 95
independence 20, 144
India 151, 154
indigenous Australians 132–3
indiscretion 134
injunctions 114
insecurity 33, 104
International Business Owners Survey 2, 30
International Federation of the Red Cross and Red Crescent 164, 169
International Labour Organisation 31
International Women's Day 18
interpersonal skills 76, 94
investment clubs 89–90, 142
Iraq 117
Ireland 59
Iron Lady 61, 68, 85, 160
Islam 166–7
Israel 85
Italy 31, 132

J

Jackie O 155
Japan 2–3
Jimmy Choo sandals 85
jobs in senior management 2
Jolie, Angelina 148
Jones, Anna 80–1
Jordan 155–6, 166

juggling 36, 72, 75, 147, 160

K

Keaton, Diane 148
Keyes, Marian 60
Kidman, Nicole 116, 137, 148
Kingfisher 72, 171
Knowles, Denise 119, 138–41
Koirala, Anuradha 152
Kosovo 151, 153
Kosovo Women's Initiative 153–4
Krawcheck, Sally 13, 143–4

L

Lancaster University Management School 70
Lane Fox, Martha 41, 45–8, 84
lastminute.com 41, 45–7, 84
Law Society 173
Laybourne, Geraldine 115
Lebanon 117
Lever Brothers 34
Lifetime Entertainment Services 116
little girl lost 11
Loewe, Anita 61–2, 176–7
London International Financial Futures Exchange 85
London Stock Exchange 13, 83–4, 86, 96
Lopez, Jennifer 61
loyalty 144
Lynx 34

M

Macdonald, Eleanor 41
McGee, Mollie 117
McGrath, Kathleen 154
McVey, Cynthia 118, 120–21, 129
Maddox, Brenda 160–61
Madonna 54, 116, 155
Maggie The First Lady 160
Magnum 34
Maier, Stephanie 42, 44–5
Mail and Guardian 152
Maiti Nepal 152

major industrialised nations 2
makeover 161
male secretary 51
Malik, Kenan 134
Management Centre Europe 51–2
management roles 2
manipulation 85, 125, 159
Maor, Galia 85
Marconi 87
Marie Claire 129, 135
Marks & Spencer 100
Marmite 34
marriage 163
marriage fund 163
masculinity 60
Men Are From Mars, Women Are From Venus 9
mental health 141–2
mentoring 42, 58
Mexico 2
Middle East 21, 85, 116–17, 155, 166
mining 109
Minogue, Kylie 21
Mollet, Guy 52
Monash University Centre for Women's Studies 132–3
money markets 83–97
Monopoly 93
Moore, Demi 18, 116
Morgan Grenfell and SG Asset Management 38
Mother Theresa of Nepal 152
Moulin Rouge 137
Mubarak, Suzanne 155–6, 166
multitasking 41, 49, 103
Mum's CV 36–7, 75
Muslim community 132
My Fair Lady 4

N

Nash, Carole 111
National Association of Investors Corporation 89
National Lottery Charities Board 173
natural skills 5
Natwest Everywoman

Awards 27, 110–11, 177
Navigator 58–60
Nefertiti 19
Nepal 152
Netherlands 2, 78
networking 41, 98, 109
neutering 97
new man 50, 57
New York fire department 165
niche role 132
Nicholson, John 58
Nicholson McBride 58
Nickelodeon 115
Nixon, Richard 117
Nokia 63
Norway 3, 42–3, 161–2, 167
notoriety 129

O

obstacles 8, 48, 150
Office for National Statistics 147
old boy network 4, 48, 162, 167
One Plus One Charity 147
oppression 21, 166
Oscars 114–16
Oxygen Media 115

P

Pakistan 2, 35, 151–2, 157, 164, 168–9
Palomar-Fresnedi, Rhodora 36
Pankhurst, Emmeline 132
Panorama 125
Paraskeva, Janet 173
parenting skills 75
Parker, Sarah Jessica 116
Parkinson, Cecil 160
Patak Indian food empire 15
Pearson 11
Pearson Jones 95
'people's princess' 155
Pepsi 63
perception 32, 92, 114, 171
Perfect Alibis 175
Peron, Eva 155
Peron, Juan 155

Persil 34
personal space 78
Pfeiffer, Michelle 148
Pharaoh Hatshepsut 19
Philippines 2
playground tactics 53
playing second fiddle 61
Potter, Mark 89
'Power 50' 43
power 63–4, 104, 125
power dressing 4
prejudice 33, 48, 96
Preston, Sally 99–106, 109–10, 112–13, 179
Price, Fiona 91–5, 97
Prince Charles 125, 159
Princess Grace of Monaco 155
privacy 114
problems women face 10
Professor Henry Higgins 4
promotion 16, 23–4, 34, 63, 77, 84, 122–3
Proper Care & Feeding of Husbands 9
prostitution 152
psychologists 58, 71, 99, 118, 129
Pudsey, Carol 171
pulling power 116
pushy broad 53

Q

Queen Elizabeth II 61, 83, 155, 159
Queen Hetepheres II 19
Queen Rania Al Abdullah 155–6, 166

R

Raising the Roof 175
Ralston, Julie 89–90
Rantzen, Esther 129
Rapport Unlimited 67, 77
rat race 149
Raworth, Sophie 122
reality TV 128
recognition 20
redundancy 8, 16
Relate 119, 138
relationship break-up 8, 16, 50, 57, 99, 136, 141, 147–8
relationship-style

management 71
Report on Business 43
retirement 111, 139
Ridley, Yvonne 116
Roberts, Julia 116
Robinson, Anne 127–8
Roddick, Anita 13, 16, 39
role reversal 61
Russell Reynolds Associates 14
Russia 2–3, 18, 30–1, 154

S

Saudi Arabia 35, 117
Scardino, Dame Marjorie 11, 14
Second World War 117
self-employment 73, 104
self-esteem 49, 58, 129
self-promotion 14, 41
self-respect 137
self-worth 58
senior management representation 2–3, 27, 64, 77, 96–7, 161–2
September 11 165
serial relationships 142
sexism 29, 38, 48, 96–7, 106, 127, 137
sexual harassment 50, 65
sexuality 21, 160
shared parenting 132, 176
Sharman, Alison 122–4, 126
sharpening stilettos 4
Shaw, Heather 43–4
She 74
Silicon Valley 135
singledom 134, 141
Small Business Bureau 74
Smith Barney 13, 143
Smith, Pam 33–4, 42, 45
'soft' skills 15, 32, 51
some role models 170–9
South Africa 2
Southeast Asia 30
Springboard 58
Sri Lanka 157
staying single 141
Stephen-Martin, Philippa 25–7, 177
stereotypes 4, 13–14, 27, 121, 132, 156
stigma 148

index

Streeter, Penny 101–3, 106–8, 112, 168, 178
strength 63–4, 103, 130–31, 141, 158–9
stress 65, 79
Sun 127
Sunday Express 116
superwoman 4, 22, 38, 53
support 98–113
survival skills 98–113
Sweden 54
Sweeney, Anne 115
switching careers 39
Switzerland 18

T

Taliban 116
team building 15, 32, 51, 76, 105
Thatcher, Margaret 61, 68–9, 155, 159–62
Thatcher, Sir Denis 61
3i 14
through the glass ceiling 27–48, 151
Tiananmen Square 116
time management 37
Titanic 61
Toussaint, Linda 152–3

traditional relationships 23
Traeger, James 58–60
trauma 8, 12, 99, 179
Trinity Mirror 149
true leadership 5
Turkey 152

U

UBS 85
UK *see* United Kingdom
Unilever 34–6, 44, 48, 75
United Arab Emirates 163
United Biscuits 72, 172
United Kingdom 2, 30, 59, 86, 89, 92, 108, 140
United Nations 18, 31
United States 2–3, 15, 18, 30, 54, 63, 86–9, 100, 115, 127, 140, 142–3
university of life 75
University of London 141
US Census Bureau 54, 143–4
US/USA *see* United States
USA Networks 115

V

Vacassin, Priscilla 71–2, 76, 171–2

Venues Unlimited 61–2, 176
Vinnicombe, Susan 32–3
Vodafone 87, 149
Volkswagen 52
voting rights 2

W

Wade, Rebekah 127
Wall Street 142–3
Walters, Barbara 117
war 2
Washington Mutual Bank 63
Watchdog 122–3, 176
Weakest Link 127–8
wearing the trousers 131–50
Wenham-Jones, Jane 175–6
What Women Want 9
Williams, Val 53–4
Windisch, Simon 55
Winfrey, Oprah 13, 117
Winslet, Kate 61
Woman's Own 161
Women and Company 144
women in the heart of the city 83–97

Women In Business Award 74
women on the international stage 151–69
Women in Management 33–4, 41–2, 45
women in the media 114–30
women in relationships 131–50
Women in the Workplace Agency 29
Women's IFA Group 91
women's leadership 1–12
women's role in society 7
work culture 10, 76, 78–9, 82
Working Girl 39
workplace skills 65–82
World Today 30

Y

Yates, Andy 87
Yelland, David 137

Z

Zeta-Jones, Catherine 116